素顔の動物園
The real zoological garden

熊本日日新聞社

Contents

まえがき 6

Part.1

10 チンパンジー
12 ルリコンゴウインコ
13 キンケイ
14 マサイキリン
16 ラマ
17 モモイロペリカン
18 ミナミシロサイ
19 アンゴラコロブス
20 メガネカイマン
22 シロエリオオヅル
23 シロダマジカ
24 ダチョウ
26 ベニジュケイ
28 クロジャガー
30 ムネアカカンムリバト
31 トカラヤギ
32 ホロホロチョウ
33 エリマキキツネザル
34 オウギバト
36 メンフクロウ
37 エランド
38 オシドリ
39 シシオザル
40 アオミミキジ
41 赤ちゃん仲間入り

Part.2

44 キンバト
45 オタリア

2

Contents

120 カナダガン	121 オナガキジ	122 アフリカニシキヘビ	123 シロビタイムジオウム	124 コクチョウ
125 ミミナガヤギ	126 シフゾウ	128 ニホンキジ	129 ポニー	130 ルーセットフルーツコウモリ
131 ナナクサインコ	132 ツクシガモ	133 ニホンジカ	134 クレコドリ	135 エジプトガン
136 アフリカゾウ	138 ヒツジ	139 ホオジロカンムリヅル	140 アムールトラ	142 クマモトシュ
143 キンシコウ	144 命つなぐ園内の"病院"	146 熊本地震復興へ一歩一歩	151 索引	158 あとがき

まえがき

熊本日日新聞社編集局長　丸野　真司

　動物園といえば、きっと誰もが一度は足を運んだことがあるでしょう。小さいときに手を引かれて行ったこと、学校の遠足でみんなとお弁当を食べたこと、娘や息子たちを連れて遊ばせたこと…。子どもから、お父さん、お母さん、おじいちゃん、おばあちゃんまで年齢や世代を超えて、動物園は憩いのひとときを与えてくれます。

　こんなに長く親しんできたのに、どれだけ生き物たちと真剣に向き合ってきたでしょうか。指折り数えてみても、覚えている動物の少ないこと。欲張って全部見て回ろうと急ぎ足だったのかもしれません。

　熊本日日新聞に2016年1月まで連載した「素顔の動物園」を本にまとめました。ページをめくると、どの生き物たちとも初対面のような新鮮な発見に驚かされます。

　つぶらな瞳をぱっちり開いたダチョウ、ハート形に寄り添うフラミンゴ、大きなあくびをするライオン。生き生きした表情、愉快なしぐさに、「へえ〜」や「ほお〜」の連続です。自然の妙というのでしょうか、カラフルな姿にうっとり。じっと見ていると、動物たちの"言葉"が聞こえてきそうです。

　お願いをしても、ポーズをとってくれるわけではありません。何日も何日も通い、何時間も粘った末の「瞬間」を記録したもので

す。双眼鏡を持って行けば、同じ表情や動作に出会えるかもしれません。そんなワクワク感を抱かせてくれます。

　ところが、4月14日と16日、震度7の地震が熊本を襲いました。熊本市動植物園も陥没や隆起、亀裂が走り、地中の給排水管が破損しました。獣舎は傾き、遊具類も被害を受けました。けがをした動物はいませんでしたが、食欲が落ち、余震のたびに鳴き声を上げていたそうです。ライオンやトラなどは県外へ緊急避難しました。動物たちも同じように被災し、不安な日々を過ごしているのだと思うと胸が熱くなります。

　「休園して寂しい」「いつ動物たちと会えるの」。そんな声が熊日に寄せられます。動植物園では、モルモットやウサギなどを連れて小学校に出向いています。被災した子どもたちから「かわいい」と笑顔がこぼれます。動物たちが、平穏な「日常」に寄り添ってくれる大切な存在だったことを実感します。

　熊本地震をはさんでやっと出版にこぎつけました。復旧・復興は長い道のりになるでしょうが、この本がそのお供になればと願っています。

2016年7月

「素顔の動物園」は、2015（平成27）年4月3日から2016（平成28）年1月17日まで、熊本日日新聞朝刊に掲載されたシリーズ企画です。
※文中の年齢、動植物園の担当者、施設名、動物の体長や体重は掲載当時のものです。
※掲載後、亡くなった動物は文中にその旨記載しています。

撮影・文　熊本日日新聞社編集局写真部
　　　　　横井誠　谷川剛

Part.1

めい想する "美女"

チンパンジー

霊長目ヒト科
分布 アフリカ大陸
座高 80cm
体重 約50kg

消防ホースのハンモックに寝そべるメスのカナエ。推定36歳。天窓からの柔らかい光を浴びる姿はめい想しているよう。熊本市動植物園に2011年に完成した「チンパンジー愛ランド」には、オス1匹、メス4匹が暮らす。人とのDNA塩基配列は98％以上同じ。園内では「何人」と数える。「カナエはクールな美女だけど、実は嫉妬深く寂しがり屋なんです」と飼育員の竹田正志さん（48）。

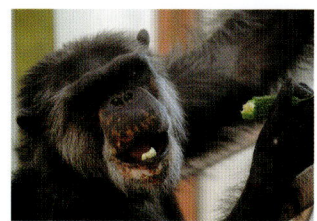

ニガウリ・大好き　チンパンジーに贈り物

熊本市動植物園(同市東区)は9月17日、園内で実ったニガウリをチンパンジー5匹にプレゼントした。同園によると、独特の苦味があるニガウリは、ニホンザルなど他の動物は口にしないが、チンパンジーだけは好物の一つ。飼育員の福原真治さん(47)から約20センチの実を2本ずつ手渡されると、ガリガリと音を立てながら、おいしそうに食べていた。ニガウリは3年前から園内のグリーンカーテンとして栽培しているが、本格的な収穫はことしが初めて。5匹が丸かじりする姿に、「来年も栽培しがいがあります」と同園職員らも笑顔だった。

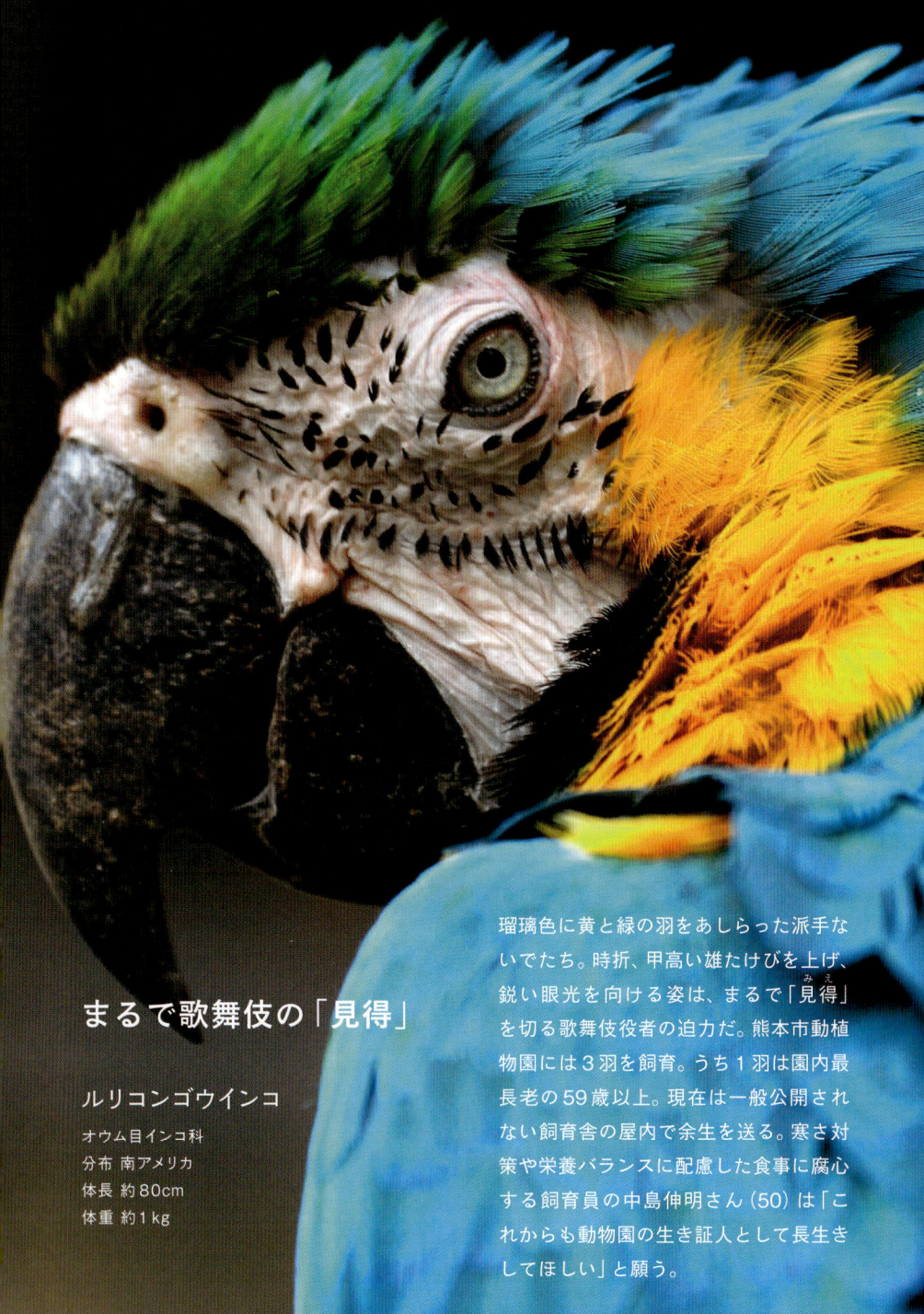

まるで歌舞伎の「見得」

ルリコンゴウインコ

オウム目インコ科
分布 南アメリカ
体長 約80cm
体重 約1kg

瑠璃色に黄と緑の羽をあしらった派手ないでたち。時折、甲高い雄たけびを上げ、鋭い眼光を向ける姿は、まるで「見得」を切る歌舞伎役者の迫力だ。熊本市動植物園には3羽を飼育。うち1羽は園内最長老の59歳以上。現在は一般公開されない飼育舎の屋内で余生を送る。寒さ対策や栄養バランスに配慮した食事に腐心する飼育員の中島伸明さん（50）は「これからも動物園の生き証人として長生きしてほしい」と願う。

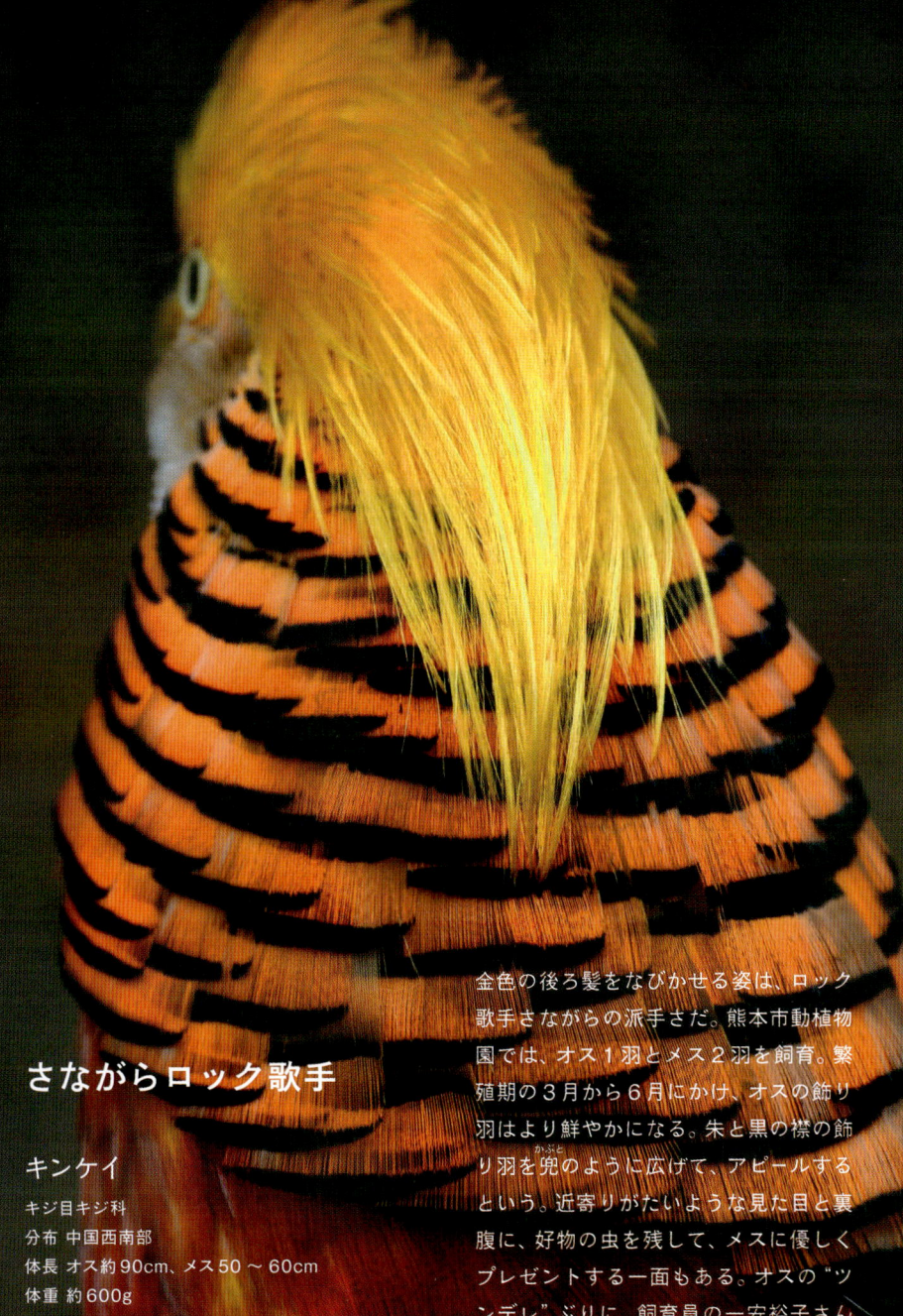

さながらロック歌手

キンケイ
キジ目キジ科
分布 中国西南部
体長 オス約90cm、メス 50〜60cm
体重 約600g

金色の後ろ髪をなびかせる姿は、ロック歌手さながらの派手さだ。熊本市動植物園では、オス1羽とメス2羽を飼育。繁殖期の3月から6月にかけ、オスの飾り羽はより鮮やかになる。朱と黒の襟の飾り羽を兜のように広げて、アピールするという。近寄りがたいような見た目と裏腹に、好物の虫を残して、メスに優しくプレゼントする一面もある。オスの"ツンデレ"ぶりに、飼育員の一安裕子さん（35）も「うらやましい」とメロメロだ。

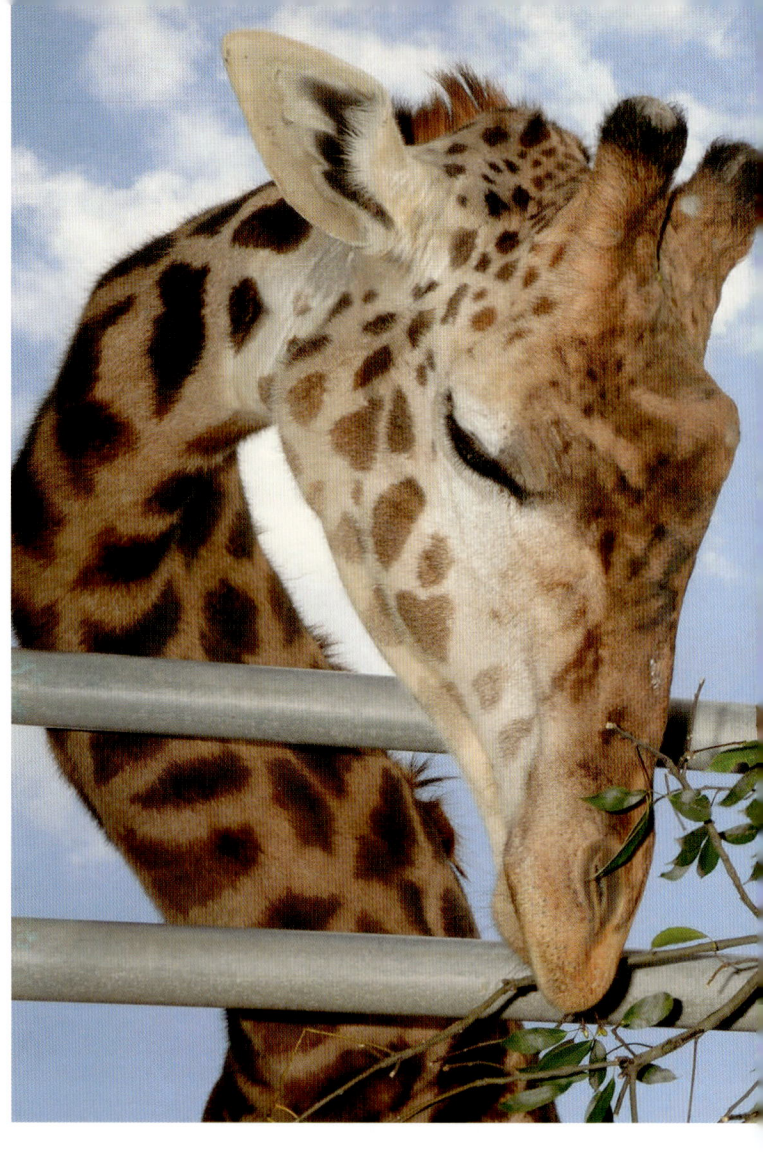

幻の鳴き声「モ〜」

マサイキリン
偶蹄目キリン科
分布 ケニアなど
頭まで 高さ約5m
体重 約1t

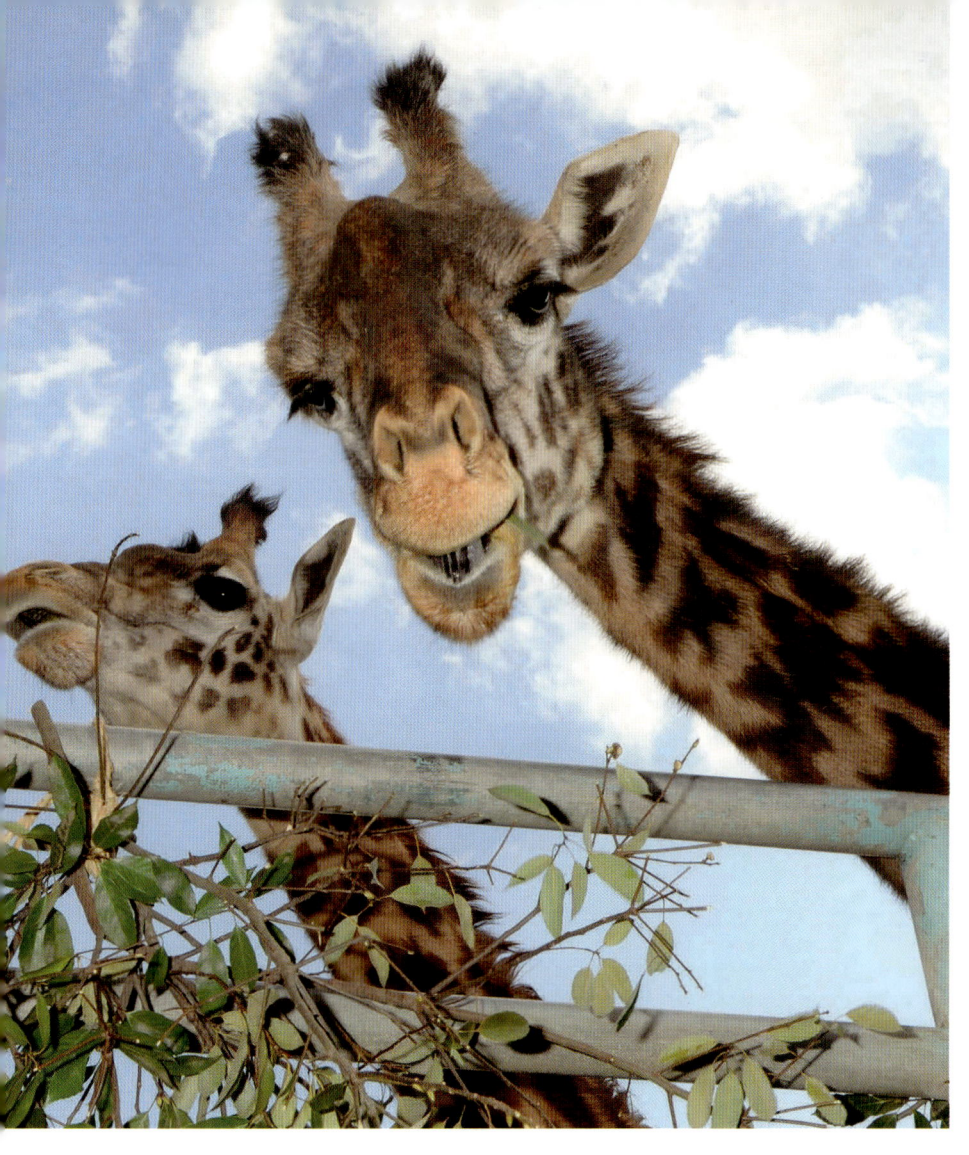

熊本市動植物園で、高さ3メートルの柵に置かれたカシの葉を、長い首を伸ばして仲良く食べているのは、左からメスのラン（20）と小春（8）、オスのリキ（7）の3頭。マサイキリンは日本に13頭しかおらず、ランが国内最高齢だ。同園によると、キリンの鳴き声は、牛とそっくりらしいが、めったに発しない"幻の鳴き声"。20年以上飼育員を務める松本松男さん（48）ですら「他園の録音資料で聞いたことがあるだけで、園では一度も聞いたことがないんです」と打ち明けるほどだ。

作戦会議の真っ最中？

ラマ
偶蹄目ラクダ科
　ぐうてい
分布 南アメリカ
体長 約2m
体重 70〜140kg

顔を寄せ、ひそひそ話をしているようなのは、ポコ（左、16歳メス）とマーチ（12歳同）。作戦会議の真っ最中か。熊本市動植物園にはメス3頭がいる。長いまつげにうるんだ瞳はおとなしそうな印象だが、驚いた時や、"新顔"の実習生らが飼育舎に近づいた時は、走り寄って胃液を口から唾のように吹き掛け威嚇する。飼育員の戸田広幸さん（49）は「酷暑の夏場は体毛をバリカン刈りするが、唾をかけられないようにラマの頭を麻布で覆って作業する」と秘策を教えてくれた。

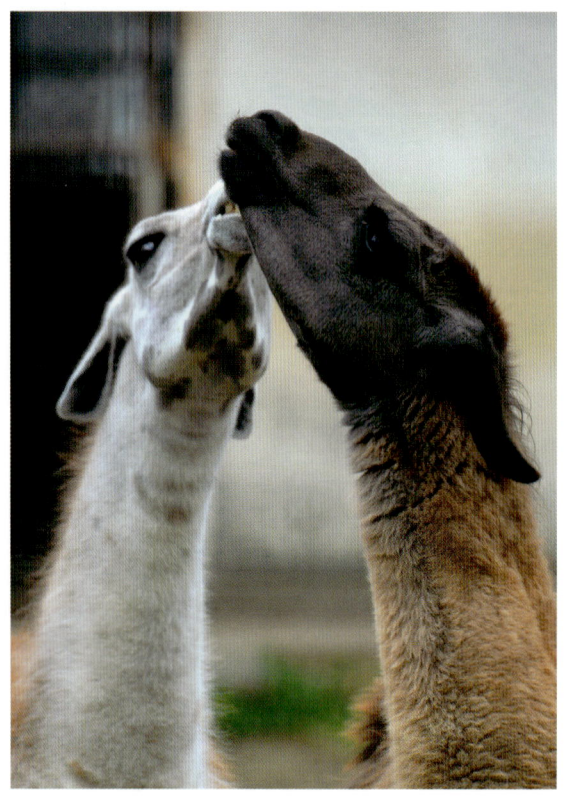

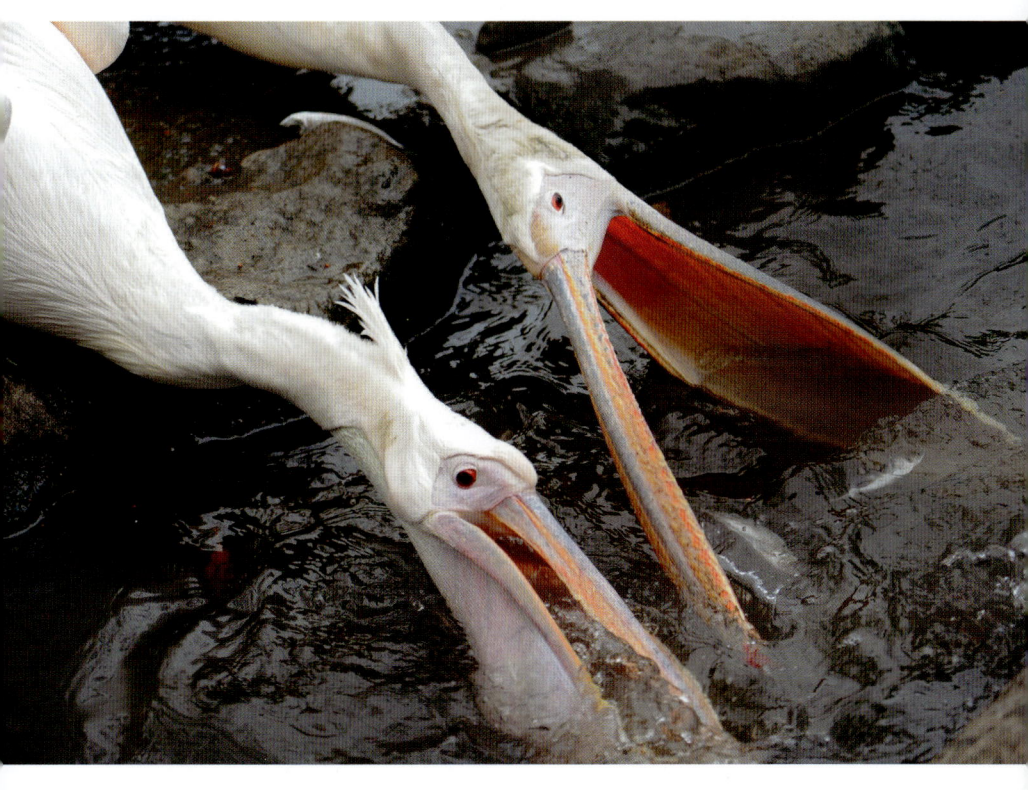

大きな口で豪快食事

モモイロペリカン
ペリカン目ペリカン科
分布 アフリカ北部など
体長 約160cm
体重 5〜10kg

「食事風景を一度見てみて。豪快に魚をすくい上げ、水だけ外に出すんです」と飼育員の長野祐太さん(29)が教えてくれた。熊本市動植物園では2羽を飼育。長野さんが餌を投げ入れると、2羽は競って水中にくちばしを突っ込み、顔を横向きにして大量の水ごとバケツのような口の中へ。器用に水だけピューっと吹き出し、一網打尽にした魚だけ飲み込んだ。食事は毎朝午前9時すぎの1回。1羽で20センチのアジを約50匹食べる大食漢だ。羽を広げると3メートル近くある。

17

触られるのが大好き？

ミナミシロサイ
奇蹄目サイ科
分布 南アフリカなど
体長 約4m
体重 1.5〜3.5t

「手触りがザラザラしてる」。子どもたちを大喜びさせているのはメスのめぐみ（35歳）。人の声が聞こえると、柵ぎりぎりまで近寄っていくことが多い。大きな体を触ってもらうのを楽しんでいるようで、愛嬌たっぷりの人気者だ。母親が米国の動物園から熊本市動植物園に来園時、おなかの中にいて同園で生まれた。主食は干し草だが、おからが大好きで毎日5キロをぺろり。飼育員の高田桂史さん（42）は「実はめぐみの耳アカはガムのような甘い匂いがするんですよ」とささやいた。

※2016年1月死す

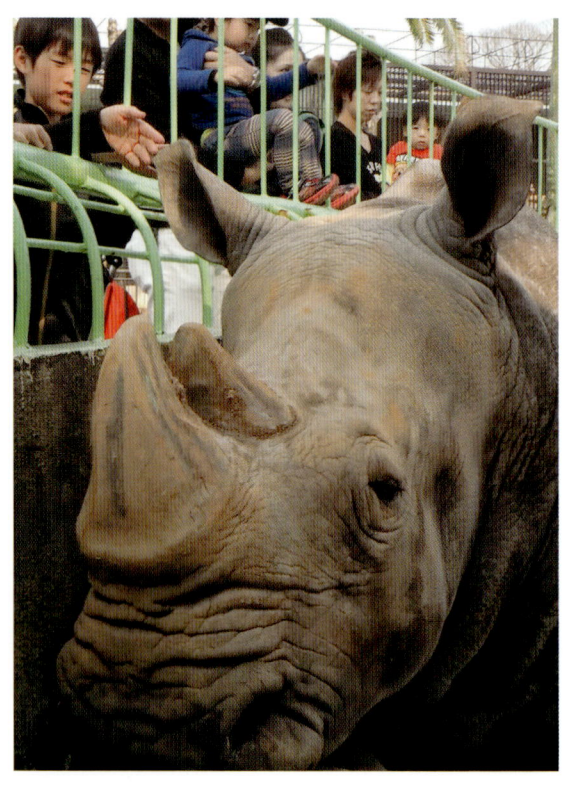

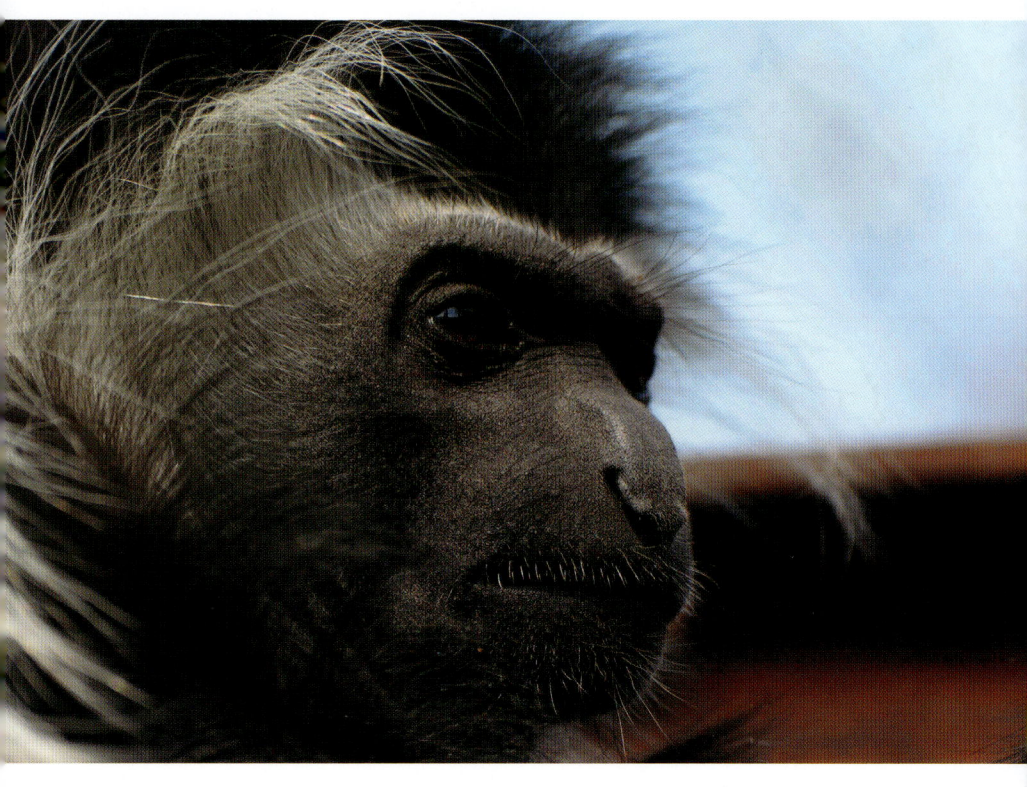

こびない哀愁の武士

アンゴラコロブス

霊長目オナガザル科
分布 アンゴラ北部など
体長 約70cm
体重 オス約10kg、メス約8kg

すきを与えない鋭い眼光で警戒する「ハットリくん」(21歳、オス)。顔の周りの白い毛をなびかせる姿は哀愁すら漂う。熊本市動植物園では、メスのティース(16歳)とチビ(15歳)と3匹で暮らす。園内にあるカシや桜などの葉が主食で、毎日、枝から切り出して与える。別名「リーフイーター」。飼育員の穴見浩志さん(42)は「他の動物と違い、毎日接しても、こびてまで餌をもらいにこない」。武士は食わねどーもののふに通じるプライドか。

水面に光る鋭い目

メガネカイマン

ワニ目アリゲーター科
分布 南アメリカなど
体長 約2m
体重 約70kg

水面に鋭く黄色い目がギラリと光る。目と目の間の眼鏡のような隆起が名前の由来だ。熊本市動植物園では3匹を飼育。毎週火・金曜日の昼時には迫力の食事風景を見ることができる。馬肉や鶏頭を棒の先に付けた針金に下げて鼻先に近づけると、大きな口でバクっと食らい付く。飼育員の内田英敏さん(42)は「月数回だけ、3匹同時に背中を振動させることがある。ブーブーと大きな音が響き、びっくりしますよ」。

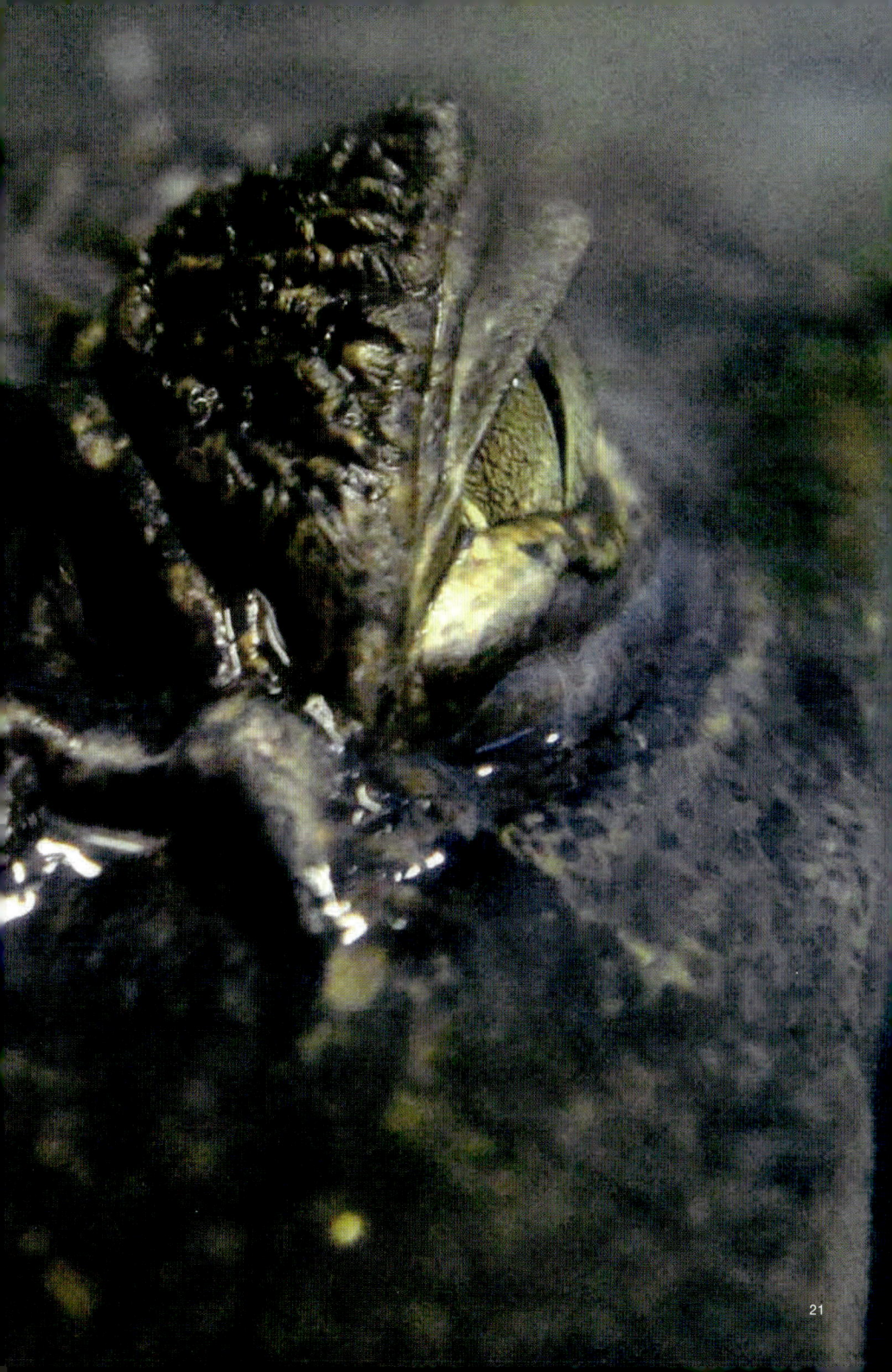

子ども見下ろす
全長1.5メートル

シロエリオオヅル

ツル目ツル科
分布 インドなど
全長 約1.5m
体重 約3.5kg

世界最大のツルで、子どもたちを見下ろす姿は貫禄十分。頭部は白く、目の周りから首の上部にかけた真っ赤な体色が特徴だ。熊本市動植物園では、シロー（オス）とエリー（メス）を飼育。2013年の12月に2羽をネット越しにお見合いさせ、つがいにした。赤ちゃん誕生を心待ちにしている。飼育員の山部哲也さん（45）から「名前の由来に気付きました？」と尋ねられた。少し考えて「シロ」「エリ」だと気付いた後、「赤ちゃんの名前はどうするのだろう」と余計な心配をしてしまった。

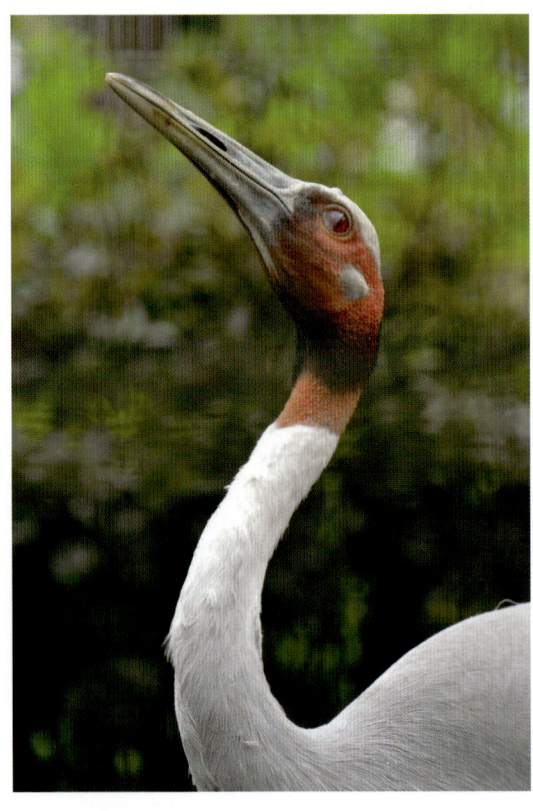

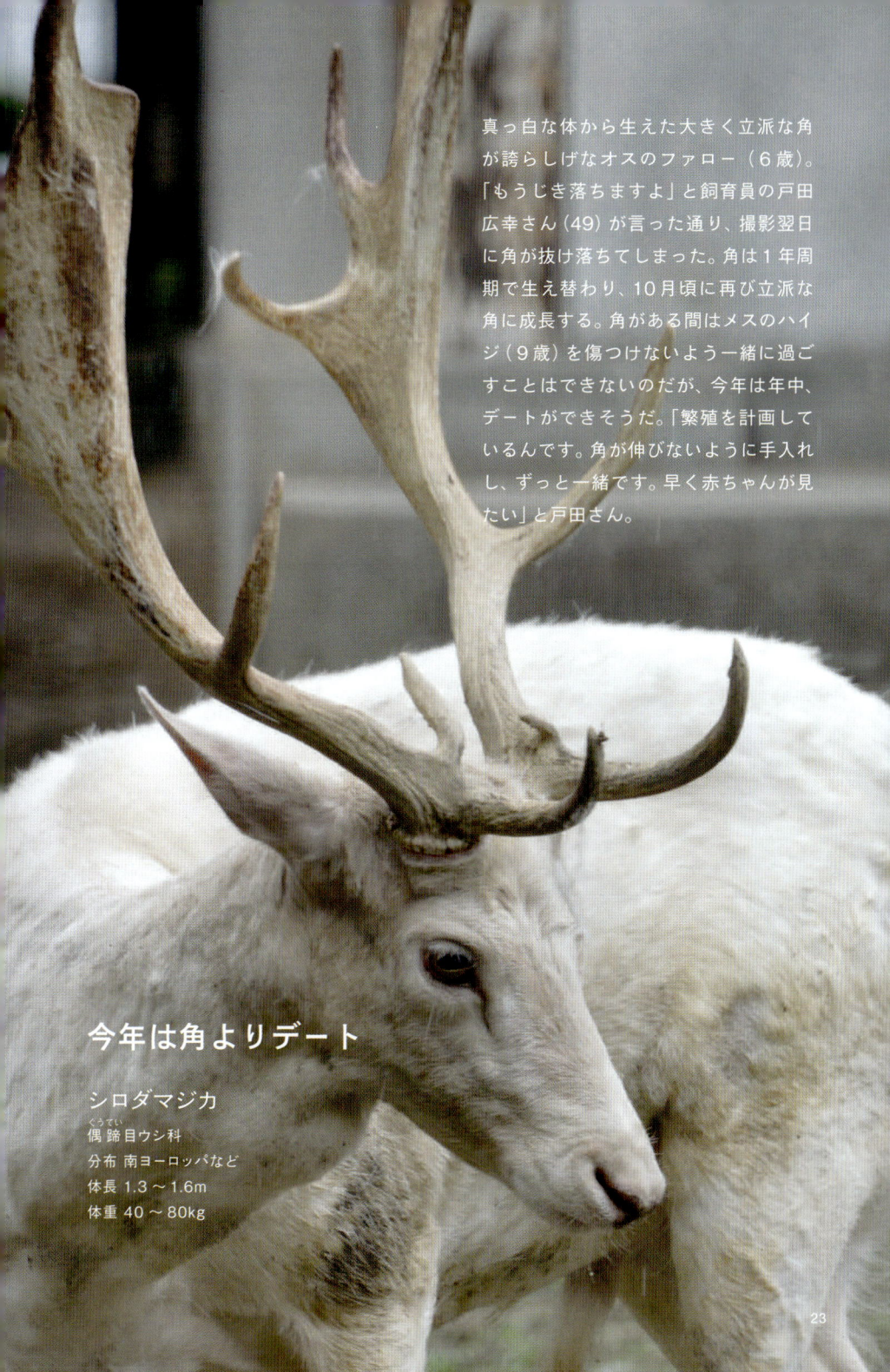

真っ白な体から生えた大きく立派な角が誇らしげなオスのファロー（6歳）。「もうじき落ちますよ」と飼育員の戸田広幸さん（49）が言った通り、撮影翌日に角が抜け落ちてしまった。角は1年周期で生え替わり、10月頃に再び立派な角に成長する。角がある間はメスのハイジ（9歳）を傷つけないよう一緒に過ごすことはできないのだが、今年は年中、デートができそうだ。「繁殖を計画しているんです。角が伸びないように手入れし、ずっと一緒です。早く赤ちゃんが見たい」と戸田さん。

今年は角よりデート

シロダマジカ
偶蹄目ウシ科
分布 南ヨーロッパなど
体長 1.3～1.6m
体重 40～80kg

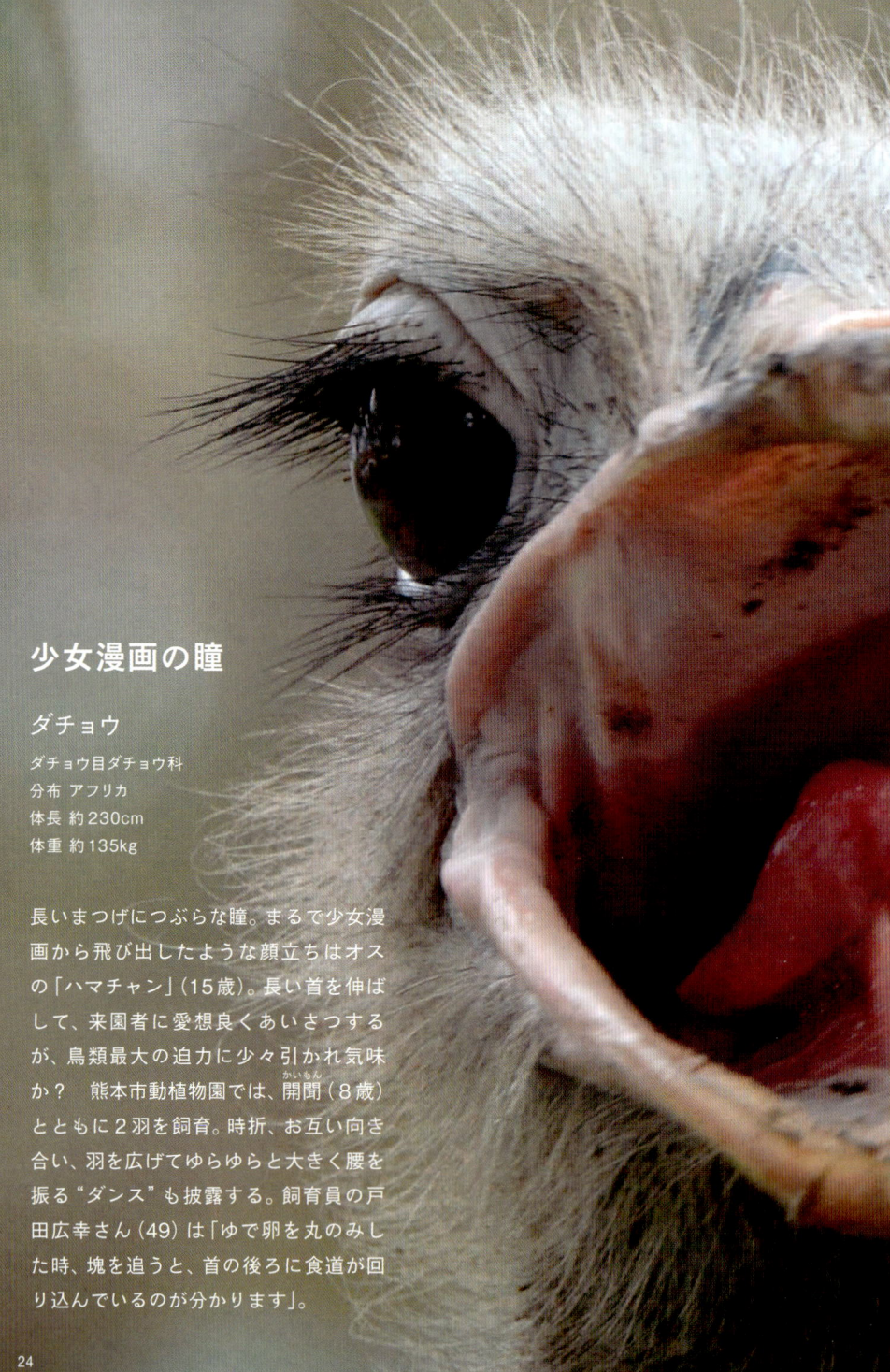

少女漫画の瞳

ダチョウ
ダチョウ目ダチョウ科
分布 アフリカ
体長 約230cm
体重 約135kg

長いまつげにつぶらな瞳。まるで少女漫画から飛び出したような顔立ちはオスの「ハマチャン」(15歳)。長い首を伸ばして、来園者に愛想良くあいさつするが、鳥類最大の迫力に少々引かれ気味か？　熊本市動植物園では、開聞（かいもん）（8歳）とともに2羽を飼育。時折、お互い向き合い、羽を広げてゆらゆらと大きく腰を振る"ダンス"も披露する。飼育員の戸田広幸さん(49)は「ゆで卵を丸のみした時、塊を追うと、首の後ろに食道が回り込んでいるのが分かります」。

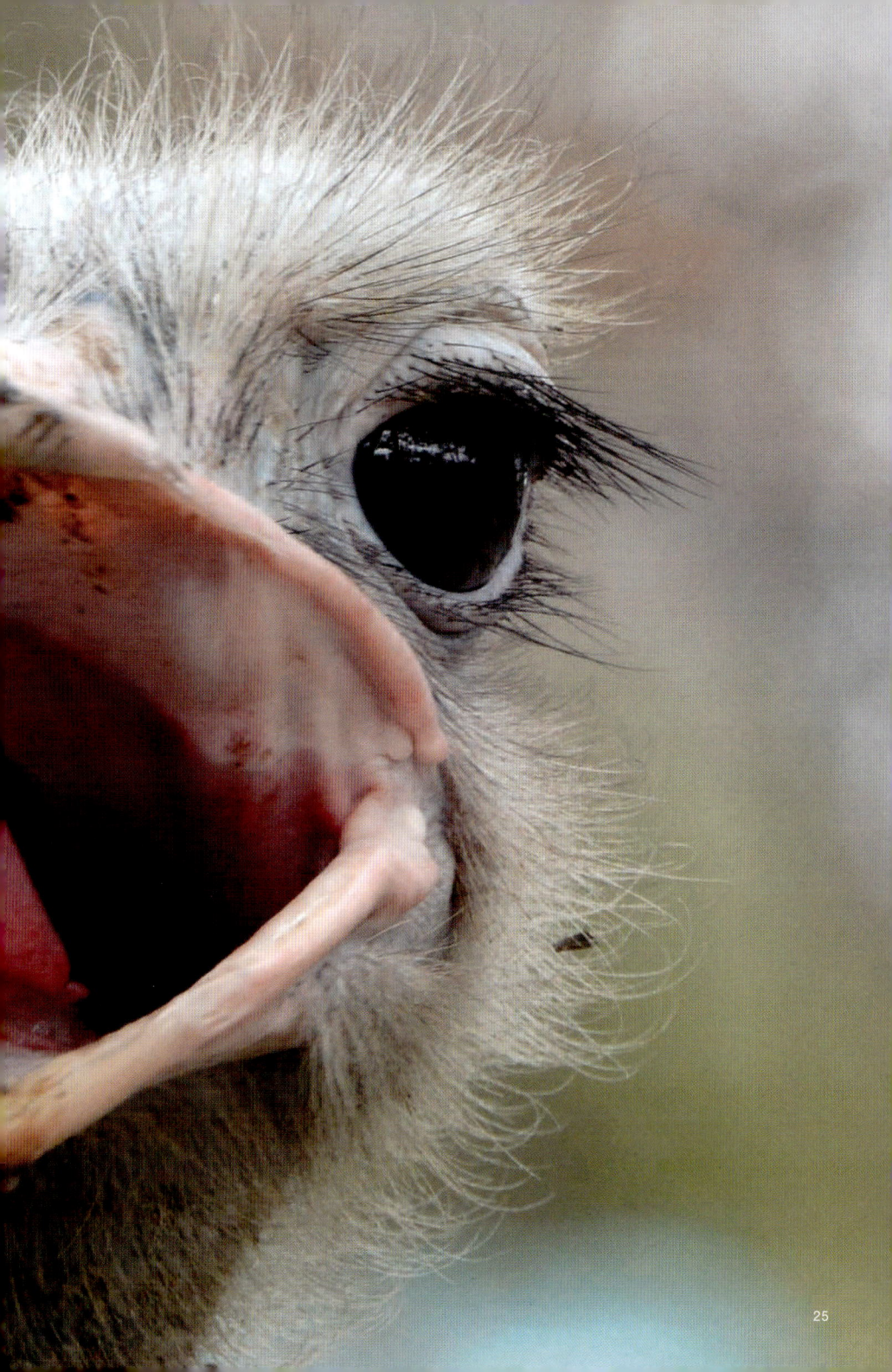

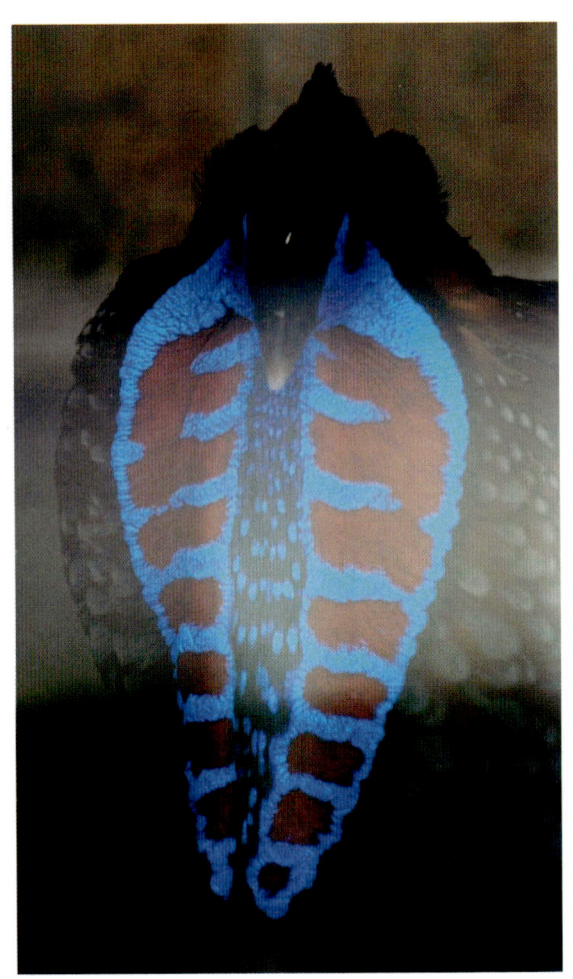

撮った！
秘密の肉垂れ

ベニジュケイ

キジ目キジ科
分布 中国など
体長 50～60cm
体重 1～1.5kg

熊本市動植物園の来場者が途切れた午後、「カッ、カッ」という音が聞こえ、飼育舎をのぞいた。オスが激しく首を振り、喉から赤と青の肉垂れをエプロンのように広げている。だが、撮影しようとすると、瞬く間に縮んでしまった。別の日、気配を消して撮影に成功。写真右から左へ肉垂れが伸びた。飼育員歴15年の一安裕子さん（35）に話すと「人前では見せない繁殖期の行動。飼育員も見たことがない瞬間です」と興奮気味だった。オスとメス各1羽を飼育。繁殖期は6月まで。

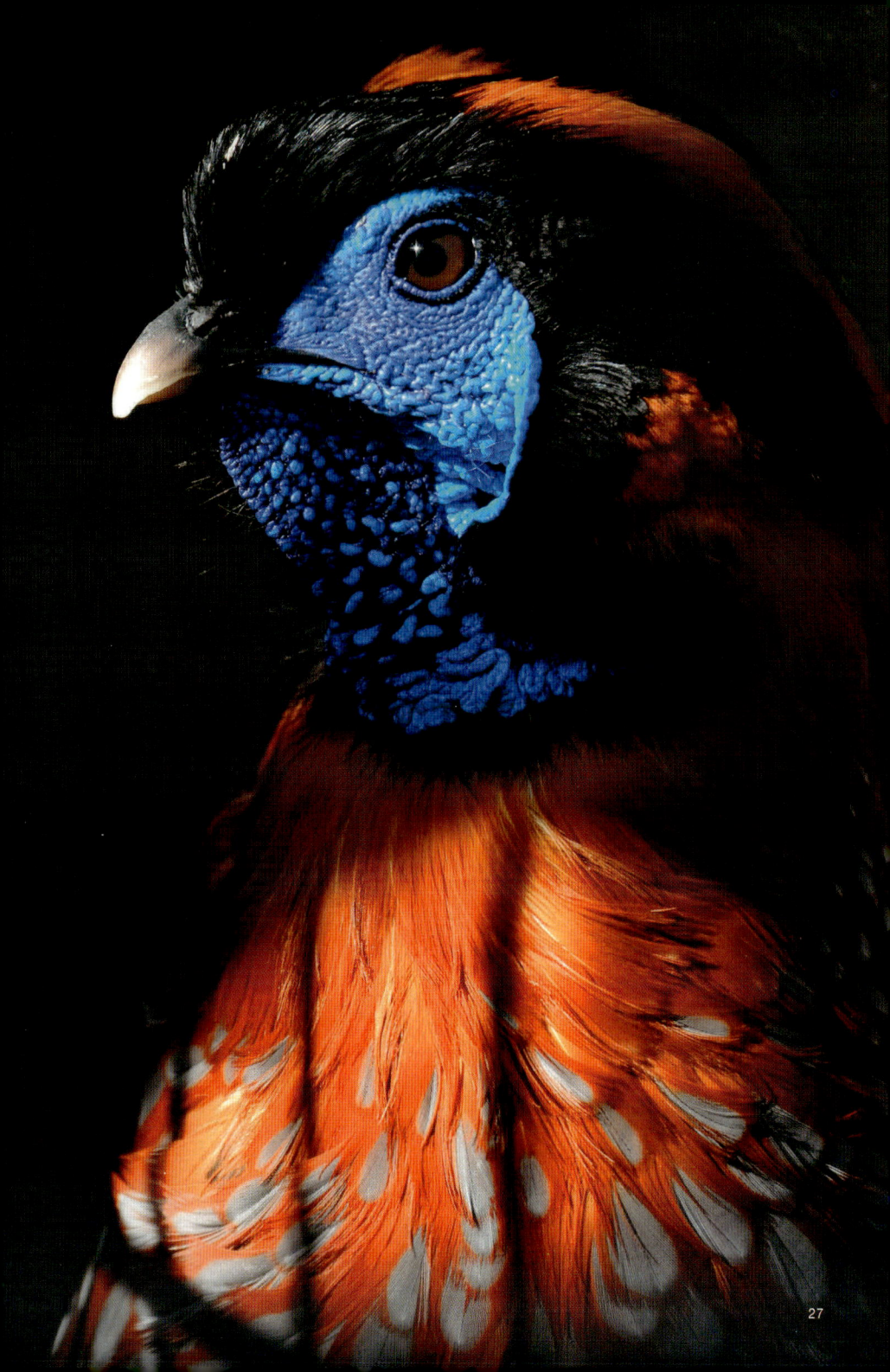

国内最高齢　神々しく

クロジャガー
食肉目ネコ科
分布 北アメリカ南部
体調 1.2～1.8m
体重 60～130kg

　クロジャガーで国内最高齢のチャペ（オス・24歳）は、人間ならばほぼ100歳。暖かい日中以外は寝室で過ごすことが増えた。左目は見えず、牙もすり減ったが、暗がりから悠々と現れる姿は神々しくもある。熊本市動植物園によると、国内記録は2014年3月まで生きた京都市動物園のオスの25歳10カ月。チャペは2016年1月8日で25歳になる。食欲はなお旺盛だ。飼育員伊藤礼一さん（49）は肉球も保湿オイルでケアしてあげながら、「1日でも長生きして」と願う。
　※2015年6月死す

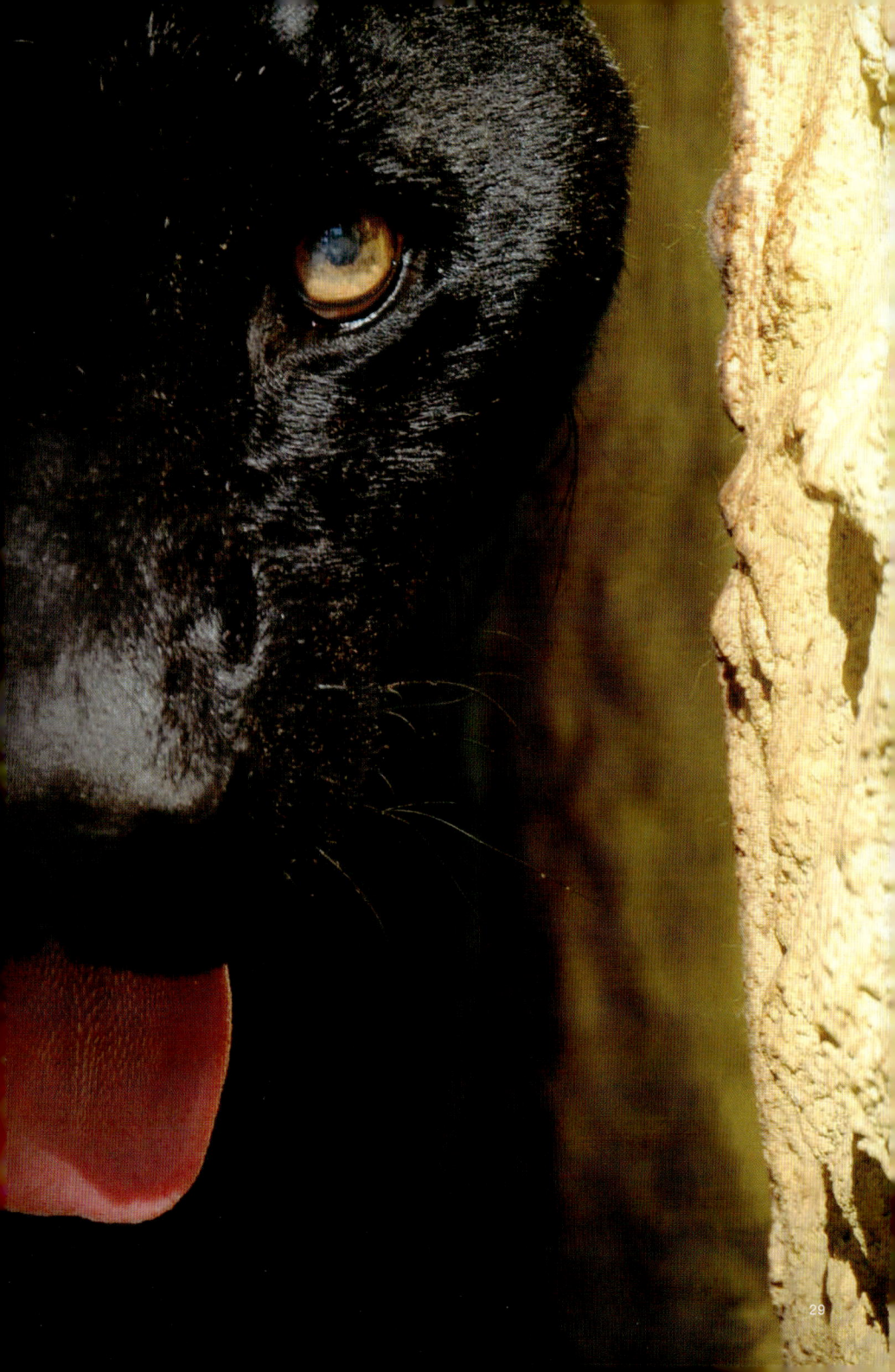

サスペンスの一場面？

ムネアカカンムリバト

ハト目ハト科
分布 ニューギニア島
体長 約75cm

ハトの仲間では最大級で、頭に青いレースのような飾り羽をまとい、胸部は赤紫の羽で覆う。黒目の周りが真っ赤で、サスペンス映画の一場面をほうふつとさせる。国内での飼育は熊本市動植物園のみで、パプアニューギニア館に3羽がいる。性別は不明。少々恐ろしげな外見とは裏腹に、同室のキンバトとけんかもせず仲良し。ハクサイやリンゴなどを食べるが、飼育員の西田知弘さん（53）は「餌をわざとこぼして食べるんです。美しい見た目にふさわしく、もう少し行儀良くしてくれたら」と愚痴をこぼしていた。

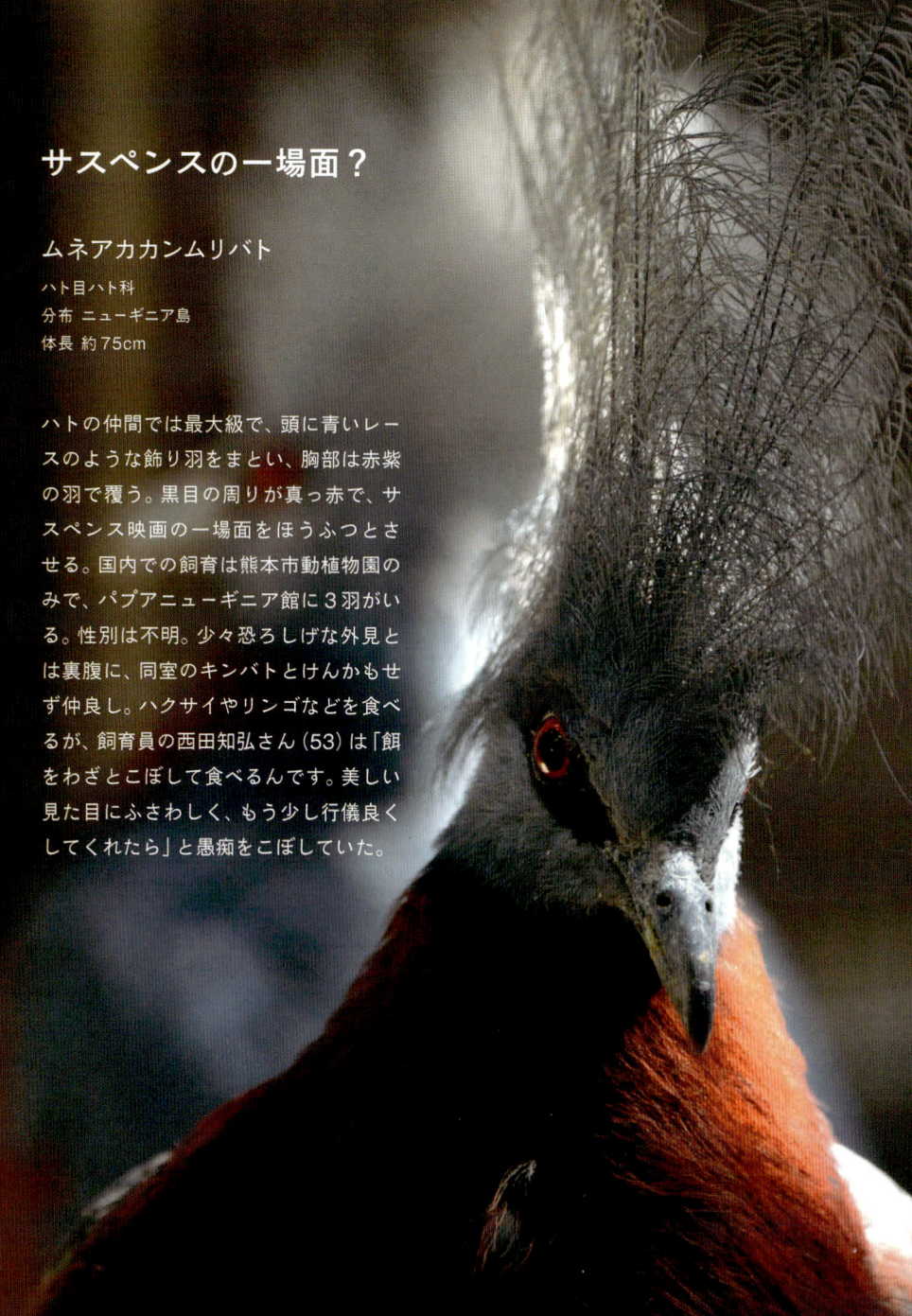

メスにもある
立派なひげ

トカラヤギ
偶蹄目ウシ科
分布 トカラ列島、奄美諸島など
体重 25～35kg

立派な長いひげ。みんなひげがある。オスばかりのようにも見えるが、「メスにもひげがあるんです」と飼育員の久保英明さん(55)。角はオスよりメスの方が短い。熊本市動植物園の飼育施設には、くいやイスで作った運動用の器具も設置してあるが、横たわって日なたぼっこするのがお気に入りのよう。眠たそうな目でまどろんでいる。普段はヤギらしく『メェー』と鳴くが、興奮したときは『ギャー』と驚くような声を出す。毎日午前10時半～午後3時には、園内の動物ふれあい広場にお目見えする。

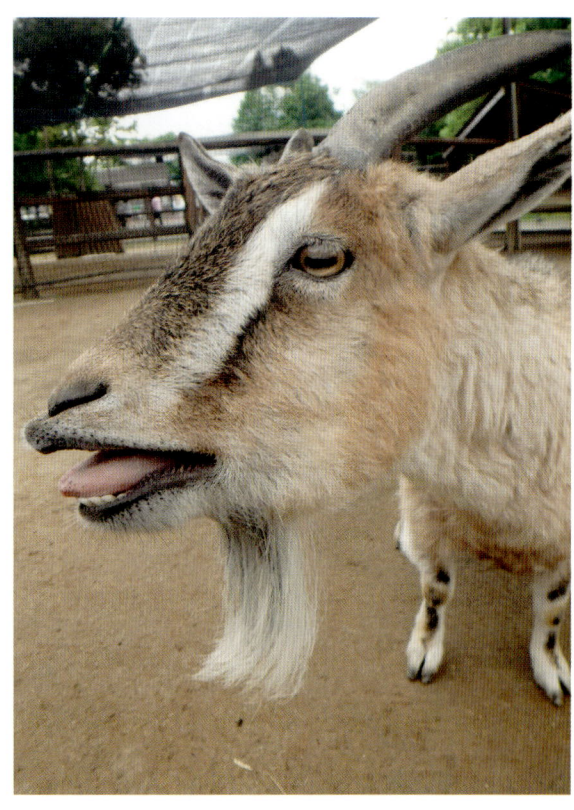

見た目よりも健脚

ホロホロチョウ

キジ目キジ科
分布 アフリカ
体長 約60cm
体重 1〜1.5kg

正面から見ると、ボールのような真ん丸の体。お世辞にも運動神経が良さそうではないが、前傾姿勢でニワトリよりも速く走る。野生では1日数十キロを歩くこともある健脚だ。熊本市動植物園には2014年人工ふ化した7羽が加わり、計13羽がいる。毛のない小さな頭に角のような突起、くちばしの両脇に肉垂れ…独特の顔立ちだが、飼育員の長野祐太さん（29）は「色白で鼻筋も通っていて、かわいいんです」と譲らない。

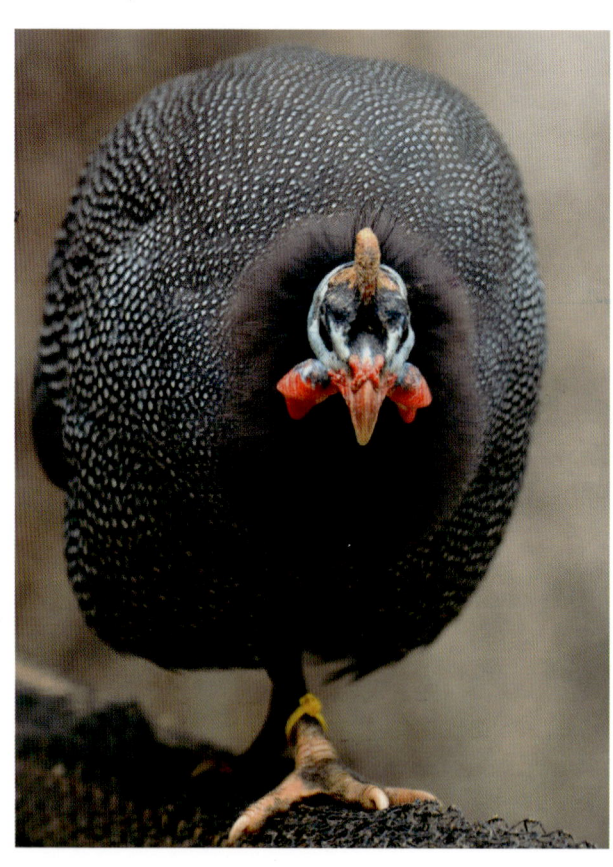

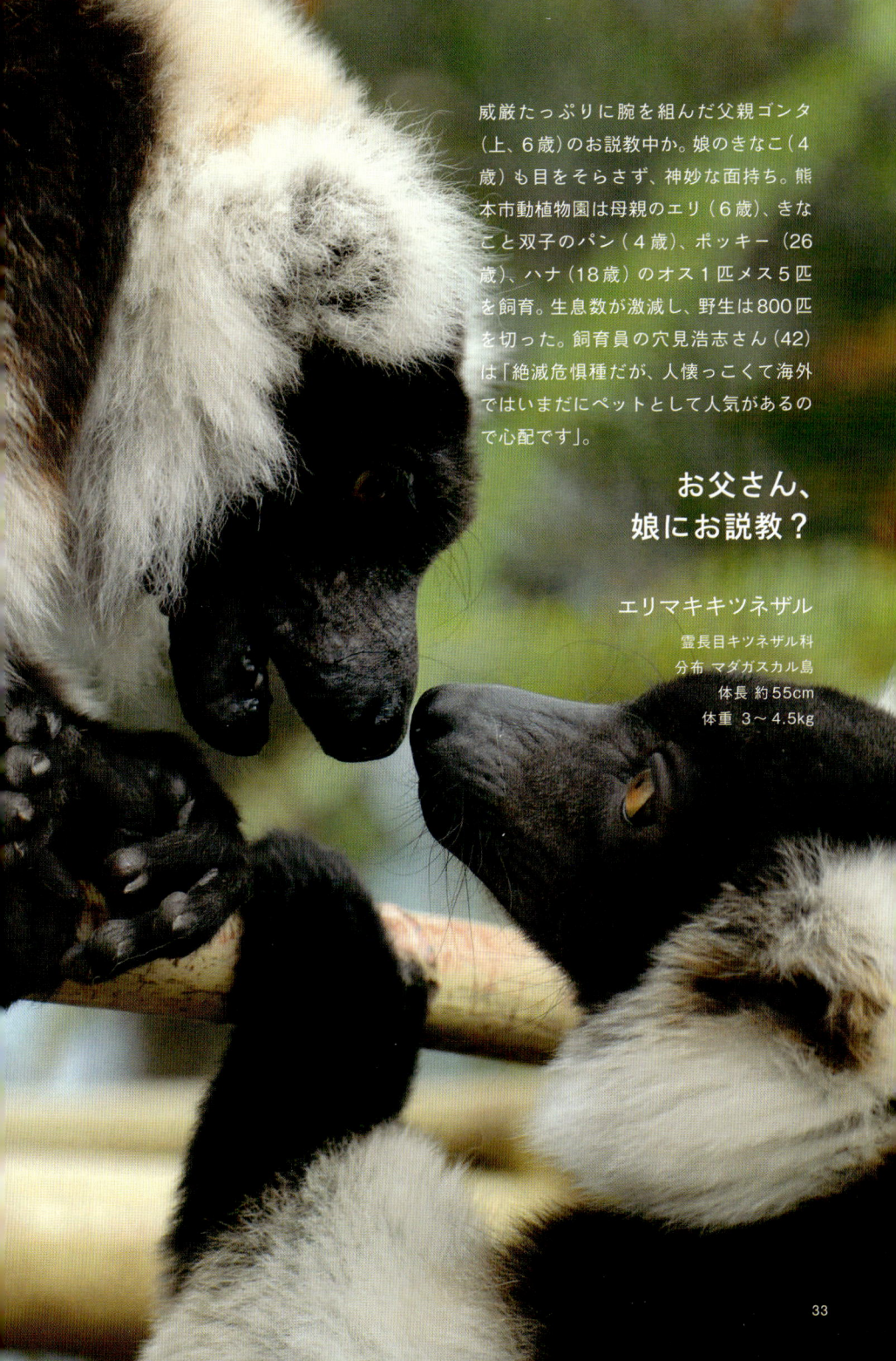

威厳たっぷりに腕を組んだ父親ゴンタ（上、6歳）のお説教中か。娘のきなこ（4歳）も目をそらさず、神妙な面持ち。熊本市動植物園は母親のエリ（6歳）、きなこと双子のパン（4歳）、ポッキー（26歳）、ハナ（18歳）のオス1匹メス5匹を飼育。生息数が激減し、野生は800匹を切った。飼育員の穴見浩志さん（42）は「絶滅危惧種だが、人懐っこくて海外ではいまだにペットとして人気があるので心配です」。

お父さん、娘にお説教？

エリマキキツネザル

霊長目キツネザル科
分布 マダガスカル島
体長 約55cm
体重 3〜4.5kg

飾り羽、パリコレ級

オウギバト

ハト目ハト科
分布 ニューギニア島など
体長 約65cm
体重 約2.5kg

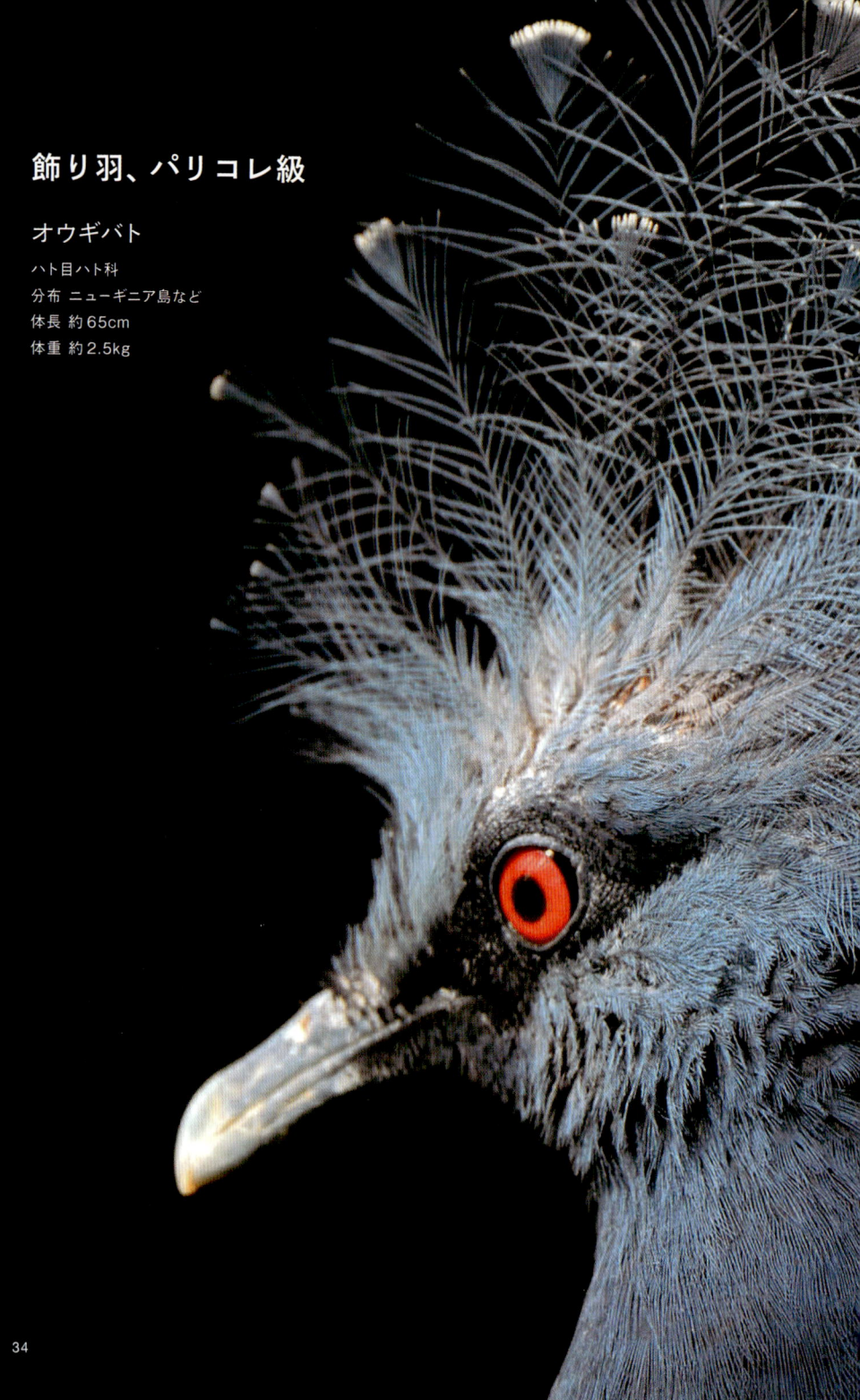

陽光に照らされたゴージャスな飾り羽。漆黒をバックにたたずむ姿は、パリコレ一流ファッションモデル級の華やかさ。よく似ているムネアカカンムリバトには飾り羽の扇がない。熊本市動植物園のパプアニューギニア館でオス2羽（29歳、6歳）、メス1羽（7歳）を飼育。同園は国内11園・33羽の戸籍簿を作り、全国の血統を管理して繁殖計画を進める。飼育員の松本充史さん（43）は「まだ熊本では繁殖実績がない。近年中に成功し、他園との連携で絶滅危惧種を保全したい」。

暗がりにハート形の面

メンフクロウ

フクロウ目メンフクロウ科
分布 サハラ砂漠を除く全世界
体長 35〜40cm

薄暗い部屋の中で静かに枝に止まっている。ガラス越しに見詰めると、じっと見返してきた。こちらの胸の内を見透かされているような気分だ。熊本市動植物園では、夜行性のフクロウの昼夜の違いを楽しめるよう、午前中だけ照明を付け、午後1時ごろに消すようにして展示している。名前通り、顔が白い面を付けたようで、オペラ座の怪人を連想させるが、ハートの形の面は「かわいい」と来園者に人気。「おしっこでガラスが汚れやすく大変」と飼育員の西田知弘さん(53)は掃除に追われる。

※2016年2月死す

ねじれながら伸びる角

エランド
偶蹄目ウシ科
分布 アフリカ東南部
体長 2.5～3.5m
体重 400～900kg

約65センチの立派な角。大きな目の整った顔立ちはシカのようだが、上下の歯をすり合わせるように食べる姿を見て、ウシ科だと納得。2014年11月に札幌市の円山動物園から熊本市動植物園に来たオスのサンタ（3歳）。名前はソリを引くトナカイのイメージではなく、3番目に生まれたからだという。角は小さい頃は真っすぐで、ねじれながら伸びていく。ウシと同様に抜け落ちることはない。飼育員の高田桂史さん（42）は「跳躍力があり、1.5メートルぐらいは簡単に飛び越えます」。

仲むつまじさ
産卵まで

オシドリ

ガンカモ目ガンカモ科
分布 東アジア
体長 40〜50cm
体重 500〜600g

「おしどり夫婦」の由来だが、生涯仲むつまじいわけではないという。夫婦になるとオスはメスを他のオスや天敵から守るため、かたときも離れず寄り添うが、産卵と同時に夫婦を解消。次季には別のメスを探して回る。熊本市動植物園ではオス6羽、メス4羽を飼育。繁殖期を過ぎるとオスの派手さは消え、灰色っぽいメスと区別が付きにくくなる。「他の鳥と違い、いじめ合ったりしない平和主義」と飼育員の松村公子さん（32）。「ほめられると照れるなぁ」とばかりに、水掻きでオスが頭をかいた。

歌って踊れる？
3匹

シシオザル
霊長目オナガザル科
分布 インド
体長 46〜66cm
体重 3〜10kg

怒っているように見えるかもしれないが、実はあくびの最中。立派なたてがみに加え、尾の先が房状になっており、ライオンを連想させることが名前の由来になった。生息数は2000〜3000匹とされ、絶滅危惧種。熊本市動植物園のオス3匹は、ボスの「ツバサ」と「ゴロー」「タクヤ」。ジャニーズ好きだった飼育員が名付けたらしい。「ツバサとタクヤがよくケンカして、ゴローは離れて静観しています」と飼育員の中島伸明さん(50)。

白いひげ「えっへん」

アオミミキジ

キジ目キジ科
分布 中国
体長 約90cm
体重 1.5〜2kg

頬から後方へ伸びた白い羽毛が、何よりも目を引く。この羽を耳に見立てたのが名前の由来だが、立派なひげを蓄えた紳士にも見える。胸を張って「えっへん」とせき払いしそうだ。熊本市動植物園では、オス1羽とメス1羽を飼育。中国・桂林市から友好都市20周年記念で1999年に来園した。熊本市からは10周年の時、シマウマとフラミンゴが贈られている。爪の長い方がオス、短いのがメスと見分ける。オスは繁殖期の4〜6月ごろにのけぞるように姿勢を正し、メスにアピールする。午前10時ごろが盛ん。

夏休み特集

赤ちゃん仲間入り

春から夏の出産ラッシュも一段落。今年も熊本市動植物園に、かわいらしい赤ちゃんたちがデビューした。園内で見つけた愛情あふれる親子の姿を紹介します。

まぶしいな。寝起きかな？

アカカンガルー

母親のおなかの袋から、ひょっこり顔を出したアカカンガルーの赤ちゃん。太陽がまぶしいかのように、顔を小さな手で覆った（4月撮影）

夏休み特集 赤ちゃん仲間入り

おんぶ

ワオキツネザル
母親の背中にしがみついた生後1カ月のワオキツネザル。体は小さくても、尻尾には立派な輪模様があった（7月撮影）

離乳

ミミナガヤギ
母親に促されながら餌の匂いをかぐミミナガヤギの赤ちゃん（右）。まだ角はないが、生後約2カ月で離乳が始まる（4月撮影）

守ってあげたい

フンボルトペンギン
赤ちゃんが生まれたと聞いて、飼育舎の中に入れてもらうと、フンボルトペンギンの両親が身を乗り出し、生後30日の子どもたちを必死でかばった（4月撮影）

きずな

クロクモザル
両親の優しいまなざしに見守られたクロクモザルの赤ちゃん。やんちゃ盛りで、じっとしていないのだが、パパとママにはぴったりとくっついている（7月撮影）

Part.2

どこか宇宙人っぽく

キンバト

ハト目ハト科
分布 インドなど
体長 約25cm

「ボ・ク・ハ・コ・コ・ダ・ヨ」。大きめの目がどこか宇宙人っぽい。だからだろうか天井近くの巣箱から、そう語りかけてきそうな気がした。鮮やかな緑の羽と真っ赤なくちばしが印象的だ。熊本市動植物園では5羽を飼育。日本では宮古島以南の南西諸島に留鳥として生息し、リュウキュウキンバトの名で国の天然記念物に指定されている。1羽だけ小さいカゴに入っていた。飼育員の内田英敏さん（42）に聞くと、「けがをしたので分けましたが、寂しい思いをさせないように、皆と同じ場所にしています」と愛情たっぷり。

耳たぶ見っけ！

オタリア
鰭脚目アシカ科
分布 南アメリカ沿岸
オス 約2.6m、300kg
メス 約2m、150kg

アザラシとの違いは、小さな耳たぶがあることらしい。オスの未来（17歳）を観察していると、プールにバシャーンと飛び込んで水しぶきをかけられた。いたずら好きで、来園者によく水をかけるそうだ。熊本市動植物園には未来と、アイ（メス・23歳）、マイ（メス・16歳）がいる。後ろ脚は前向きで、アザラシは後ろ向き。「泳ぎ方はペンギンと同じで前脚で水をかいて進む。アザラシは前脚を使わず、魚と同じように体をくねらせて泳ぐんです」と飼育員の中村寿徳さん（52）。

ウエディングドレスの羽

シロクジャク
キジ目キジ科
分布 インドなど
体長 1～2m
体重 約4kg

純白の羽は、まるでウエディングドレス。飼育員の松村公子さん（32）に「私もいつか」と夢描かせる。実はオスだが、3～6月の繁殖期、尾羽を広げてメスを魅了する。羽が陽光に透けると、美しさを増した。インドクジャクの白色変種で、違いは羽の色だけ。熊本市動植物園ではオス26羽、メス14羽を飼育。1968年から飼育し、人工ふ化で世代交代させている。「ミャオー」と子猫のような鳴き声。夕方、閉園の放送が流れると、自分で寝室に戻っていく。

47

いつも一緒

カバ
偶蹄目カバ科
分布 アフリカ
体長 約3.5〜4m
体重 1〜2.5t

2015年3月に埼玉県の東武動物公園から熊本市動植物園に来た3歳のソラ（右、メス）。寄り添って日光浴する18歳のモモコ（メス）は母親のように世話を焼き、いつも一緒にいる。本来は群れで行動するが、同園は2頭のみ。将来は江津湖を借景にした運動場で、10頭の群れを飼育する計画が進んでいる。カバの生態調査のためタンザニア視察に出掛けた飼育員の北川勇夫さん（36）は「半年前まで母乳で育っていたソラは、モモコのお乳を探している。体重700キロだけど、まだ子どもです」。

人の笑い声そっくり

アカツクシガモ
ガンカモ目ガンカモ科
分布 ユーラシア大陸
体長 約65cm
体重 1〜1.4kg

「あははは…」。人の笑い声そっくりの鳴き声が聞こえ、目をやると、オスが豪快に水浴び中だった。繁殖期のオスは首に黒い首輪状の模様ができる。熊本市動植物園ではオス3羽とメス1羽を飼育。2014年4月までは放し飼いで、園中を歩き回って、飼育員に餌をねだるのが日課だった。「人懐っこくて、小さな瞳にメロメロになる」と飼育員の松村公子さん（32）。だが、自由に歩き回りすぎて、現在はクジャク舎隣にある金網張りのエリアで暮らす。

消防ホース
お気に入り

ニッポンツキノワグマ

食肉目クマ科
分布 日本
体長 120～180cm
体重 40～150kg

お気に入りの遊び道具は、「南熊本」と印刷された中古の消防ホース。桔平（オス、11歳）がかんだり引っ張ったりしても形崩れしない丈夫さはさすがだ。熊本市動植物園では、ひなた（メス、11歳）と計2頭を飼育。午前と午後、交互に運動場に出る。2頭とも2009年に阿蘇市のカドリー・ドミニオンから来園。大型犬と同じくらいの大きさだが、飼育員の西村光輝さん（57）は「クマは頭がいいので、格子の透き間から手を入れて、飼育員の服を捕まえようとする」と細心の注意を払っていた。

真っ白な全身で、頭部に黄色い羽飾りがある。ギョロリとした目もユーモラスだ。ペットとしても人気があるが、「ギャー」という大音量の鳴き声には要注意。熊本市動植物園には性別不明の1羽がいる。とてもかしこく、阿蘇市のカドリー・ドミニオンには旗揚げの芸を披露するキバタンがいる。大好物はヒマワリの種。「慣れれば触らせてくれますよ」と飼育員の内田英敏さん（42）。寿命は40〜50年と長い。

大音量の鳴き声、
要注意

キバタン

オウム目インコ科
分布 オーストラリアなど
体長 約50cm
体重 約800g

仲良く寄り添い熟睡

クロクモザル

霊長目オマキザル科
分布 南米アマゾン川流域
体長 50～60cm
体重 6～9kg

熊本市動植物園の正門正面にあるモンキーアイランド。おりのない開放展示施設で、熟睡しているのは「カンちゃん」（メス、35歳）。長女「なっちゃん」（同、17歳）も寄り添う。頭上では高さ10メートル近いヤシの木の間を家族たちが長い手足としっぽを使って遊び回るが、まったく気にならないようだ。計8匹を飼育。寿命は25～30年だが、2015年1月に死去したマコトは39年間も同園で暮らした。「天国から見守っているでしょう」と飼育員の中村寿徳さん（52）。

美しき羽、蓑のごとし

キンミノバト

ハト目ハト科
分布 東南アジア
体長 30〜35cm
体重 500〜600g

子どもたちは知らない人が多いと思うが、昔、農作業の時に使ったわらで編んだ雨具が蓑(みの)。首から背中にかけて、この蓑のように見える美しい羽を持っていることから、名前が付けられた。日本のハトより少し大きい。熊本市動植物園では、年間を通して室温25度のパプアニューギニア館で14羽を飼育。餌は野菜や果物が中心。ストレスや餌の種類でも羽の発色が違ってくるという。2015年の春はオスとメスが交代で抱卵していたが、ふ化には至らず、飼育員らを残念がらせた。

深紅のハート
完成

フラミンゴ
フラミンゴ目フラミンゴ科
分布 西インド諸島など
体長 120〜140cm
体重 2.2〜2.8kg

夫婦のベニイロフラミンゴが、細くて長い首を重ねて寄り添い合う。その瞬間、深紅のハートが完成した。熊本市動植物園ではチンパンジー舎に隣接する池で、ベニイロフラミンゴ、チリフラミンゴなど計68羽を飼育。美しい羽色を保つため、毎日の餌に、赤い色素が豊富なオキアミを混ぜて与える。プロ野球の王貞治さんが「フラミンゴ打法」と呼ばれたように、歩行時以外は一本足で生活する。水に両足を入れると冷えるので、体温調節しているという。

入った！ 豪快左パンチ

アカンガルー

有袋目カンガルー科
分布 オーストラリア
体長 120〜140cm
体重 25〜80kg

ボスに君臨するツバサ（左）の豪快な左パンチが、2番手ジョーの顔面にさく裂した。争いに勝ったオスのみが子孫を残すことができる。だが2匹は2015年4月末、血統が濃くならないようにと園外のオス2匹と交換され、この時が最後の決闘となった。熊本市動植物園では計15匹を飼育。オスは成熟すると分泌液で胸が赤く染まる。「リーダー争いを目撃した来園者から『けがして血が出ている』との通報もあるが、心配ご無用」と飼育員の平瀬早人さん（42）。

男くささ満点

ジスリ

キジ目キジ科
分布 日本
体長 50〜60cm
体重 3〜3.7kg

どこか見覚えのある顔。一世風靡(ふうび)したテレビCM「う〜ん、マンダム」のあの人かも。男くささ満点だ。幕末から明治初期にかけて作出された肥後五鶏の一種。熊本市動植物園にはつがいのオスメス1羽ずつがいる。名前はないが、飼育員は「父ちゃん、母ちゃん」と呼ぶ。気に入らないことがあると、人をつついて攻撃する父ちゃん。世話をする飼育員はたまらない。「でも餌を食べる時は、母ちゃんの顔をチラ見してから食べ始める。威張っていても恐妻家」。被害者の飼育員・松本直美さん(32)は、お返しとばかりに秘密を暴露？

肉食女子の大あくび

エゾヒグマ

食肉目クマ科
分布 北海道
体長 1.6〜2.3m
体重 120〜250kg

ごろりとあおむけになり、大あくびするのは熊本市動植物園のメスのヒメ（17歳）。日本の陸上動物の最大種だが、しょぼしょぼした目がいかにも眠たそうだ。馬肉が大好物で野菜が大嫌いな"肉食女子"。健康を気遣う飼育員は、野菜に魚粉をまぶすなど工夫し、こっそり食べさせている。「なかなか見られないですが、あおむけで腹筋運動をすることもありますよ」と飼育員の西村光輝さん（57）。目的はダイエットかパワーアップか？

餌のネズミ丸のみ

シナロアミルクヘビ
有鱗目ナミヘビ科
分布 北アメリカ東部
体長 約120cm
体重 約650g

赤白黒のけばけばしい模様は、いかにも毒ヘビっぽいが、毒はなく人にも懐いている。熊本市動植物園ではメス1匹を飼育。かつて牛小屋に出没し、牛のミルクを飲みに来ると思われたのが名前の由来とされる。食事は週に1度だけ。頭より大きな餌用の冷凍ネズミを首を左右に振りながら丸のみしていく。偶然目撃した来園者はびっくりだ。飼育員の福本綾香さん(27)は「私たちはシナちゃんと呼んでいます。1〜2カ月ごとに脱皮するが、抜け殻もしま模様が付いててかわいい」。

立派な前脚せり出して

ムツアシガメ

カメ目カメ科
分布 東南アジア
体長 55cm
体重 約22kg

後ろ脚と尾の間につめ状のうろこがあり、脚が六つあるように見えるのが名前の由来となった。熊本市動植物園では、オスメス1匹ずつ飼育している。園内イベント「わくわく動物ガイド」では、4～12月の月1回ペースで、飼育員が生態について解説。天気が良ければ、園内を散歩させるので、触れ合うこともできる。平均寿命60歳とされる中、推定年齢はともに27歳の元気盛り。のんびりしたイメージだが、意外と歩くのが速い。直径40センチの甲羅で、大きくて立派な前脚をせり出して進む姿に、子どもたちは大喜びだ。

"癒やし系" 夫婦仲良く

カピバラ
齧歯目カピバラ科
分布 南アメリカ
体長 1〜1.3m
体重 35〜65kg

ドボン。勢いよく頭から水に飛び込む5歳のユウ（左、メス）。夫の6歳のマルも後に続く。「カピバラ」ではなく「カピバラ」。熊本市動植物園で1、2を争う"癒やし系"だ。夫婦には2歳の双子がいたが、4月に血統管理のため他園へ移された。だからだろうか、今春は盛んにペアリングを繰り返した。常にユウが先に水に入って夫を誘い、目の前のお尻に誘われるようにマルが追う。飼育員の中島誠一さん（53）は「新たなベビーが誕生するかも」と期待する。

工芸品のたたずまい

ギンケイ

キジ目キジ科
分布 チベットなど
体長(尾羽込み) 1.2〜1.5m
体重 620〜850g

戦国武将の鎧兜(よろいかぶと)をほうふつとさせる白黒の飾り羽。真っ赤な冠羽も鮮やかだ。美しい工芸品のように、止まり木にたたずむ。熊本市動植物園では、つがいの2羽を飼育。長さ90センチにもなるオスの立派な尾羽は、2〜6月の繁殖期が過ぎると抜け落ち、毎年、新しく生え替わる。キジ類は土の中の虫を主食とするため、餌を足で引っかき回す習性がある。だが飼育員の古屋千尋さん(26)は「園内11種の中でギンケイだけが餌を散らさず、食事姿が一番きれい」とお気に入り。

賢者のような風格

アカミミガメ

カメ目ヌマガメ科
分布 北アメリカ中南部
体長 最大約30cm
体重 約4kg

顔をしげしげ眺めると、賢者のような風格が漂う。最長50年は生きるという。祭りの露店などでも売られているため、全国の河川に生息域を拡大、生態系を壊す恐れのある要注意外来種に指定されている。熊本市動植物園では47匹を飼育。動物資料館前の屋外の池は、涌き水の水温が18度で一定しているので、冬眠はしない。飼育員の福本綾香さん(27)は週2回ある魚の切り身の餌やりを見に来てほしいという。「餌の争奪戦が始まると、運動会みたいに素早く走り回って面白いんです」

"ビジュアル系" 面影なく

キンイロキンケイ

キジ目キジ科
分布 中国西南部
体長 50〜90cm
体重 600〜700g

「こんなに見かけが変わっちゃ、まるで結婚詐欺じゃない」。メスの嘆きが聞こえてきそうだ。2月は金髪に派手な首飾りが鮮やかな"ビジュアル系"だったが、6月末には面影もないほどに一変。キジ類のオスは春の繁殖期が終わると、飾り羽が抜け落ちるのだ。熊本市動植物園には、つがい1組がいる。「首の団子状のブツブツは新しく生える羽。だんだん伸びながら広がり、秋には美しい姿に戻る」と飼育員の立山三徳さん(52)。

後ろ姿、バルタン星人!?

モモイロインコ

オウム目インコ科
分布 オーストラリアなど
体長 35〜38cm
体重 350〜400g

普段は愛らしい顔をしているのだが、興奮したらしく、ピンク色の頭の羽を一気に逆立てた。その後ろ姿に、「ウルトラマンに出てきたバルタン星人にそっくりでしょ」と、飼育員の本田信夫さん(45)。熊本市動植物園ではパプアニューギニア館で、つがいの2羽を飼育。飼育舎の掃除の際は枝に止まってじっとしているのだが、「油断していると緑色の水気の多いフンを落とされて、『やられた』と叫ぶ」と本田さん。さすがにウルトラマンは助けに来てくれないようだ。

子どもじゃないよ

マレーグマ

食肉目クマ科
分布 マレーシアなど
体長 1～1.5m
体重 25～65kg

小さい体につぶらな瞳。「子グマかな？」と勘違いする来園者もいるが、熊本市動植物園のオスのフジ（3歳）は立派な大人だ。世界最小種のクマ。2014年11月に上野動物園からブリーディングローン（繁殖を目的とした貸借契約）で来園し、直後に左足を大けがした。「展示を休止しようと思ったほどだったのに、大好きな木製遊具で遊ばせた方がストレスが少なく、治りが順調だった」と飼育員の西村光輝さん（57）。やっぱり子どもは外で遊ぶのが一番。あっ、大人だった。

愛と友情のはざま？

サンケイ

キジ目キジ科
分布 台湾
体長 45〜70cm
体重 500〜900g

夕日が差し込む閉園間近の飼育舎で、オスが思い詰めたように自分の影と静かに向き合っていた。熊本市動植物園には、オス2羽とメス1羽がいる。目立った色彩もなく、展示されているキジ11種の中では一番地味な存在だ。長くオスだけだったが、5月に待望のメスが仲間入りした。だが、いまだにオス2羽が仲良く、メスは邪魔者扱い。「愛情より友情なのでしょうか」と飼育員の古屋千尋さん(26)。はざまに揺れる男心が影と向き合わせたのかも、と勝手に想像。

高貴な姿
全国からファン

ユキヒョウ

食肉目ネコ科
分布 ヒマラヤ山脈
体長 100〜150cm
体重 35〜55kg

熊本市動植物園のメスのスピカ(10歳)は、灰黄色に黒の斑点を散りばめた毛並みで、高貴な雰囲気を漂わせる。だが毛づくろいする姿は"猫"そのもの。人懐っこい性格で、春の繁殖期には「ミャオー」と鳴く。全国10園にしかおらず、県外から訪れる熱烈なユキヒョウファンがいる。開園から閉園まで飼育舎の前を動かない人もいるそうだ。夜行性で、暗くなると壁を使った三角跳びなど素早い動きを見せる。飼育員の伊藤礼一さん(49)は「夏休み期間中の夜間開園でぜひ見てほしい」と一押し。

水面から
にょきっと

ヤエヤマイシガメ

カメ目ヌマガメ科
分布 日本
体長 約20cm
体重 約850g

水面からにょきっと飛び出た、つぶらな瞳と目が合った。寒さが苦手で、毎年12月上旬から4カ月間、水中で冬眠する。動物相談員の村上英明さん（64）は「冬眠から目覚めると、水面に顔を出し周囲を警戒する。とても憶病な性格です」と話す。熊本市動植物園では動物資料館内でメス1匹を水槽飼育。2012年に市民がペットとして飼っていたものを譲り受けた。月に数回、日光浴のため約20メートルのベランダを散歩する。幼児が歩くくらいの速さだが、目を離すと行方不明になり、飼育員を慌てさせるらしい。

「バーコード頭」のカモ

インドガン

カモ目カモ科
分布 インドなど
体長 71〜76cm
体重 2.5〜3kg

「カモの中で一番かわいいと思います」と飼育員の松村公子さん(32)は力説するが、白地の頭部に2本の黒い筋模様があるため、飼育員の間で「バーコード」というあだ名で呼ばれている。熊本市動植物園では、9羽(性別不明)を飼育。冬になるとインドなどに南下する渡り鳥。高度8000メートル以上のヒマラヤ山脈を越えて移動することもあり、世界で最も高い所を飛ぶ鳥としても知られる。時折、飼育員に「シャー」っと舌を震わせて威嚇することがある。あだ名に怒っているのカモ？

「世界一危険な鳥」の
ウインク

ヒクイドリ

ヒクイドリ目ヒクイドリ科
分布 パプアニューギニア
体長 120〜170cm
体重 30〜60kg

「先輩から世界で一番危険な鳥と教わってきた」と飼育員の内田英敏さん（42）も恐れる。目が合うと、左目だけ真っ青な瞬膜を下ろしウインクされた。片目だけの瞬間は珍しいらしい。金色の硬いかぶとに真っ青な顔と首、さらには真っ赤な肉だれ。火を食べているように見えるので「火喰い鳥」。鋭い爪での足蹴りは、敵の腹を切り裂く威力がある。熊本市動植物園では性別不明のジアとリクの2羽を飼育。同園では1977年、日本で初めて人工繁殖に成功した。実は抱卵も子育てもオスが受け持つ"イクメン"だ。

夏休み特集
夜の姿も魅力的

熊本市動植物園の夏休み期間中の人気イベント「夜間開園」。閉園時間を午後5時から午後9時まで延長し、夜行性の動物たちが活発に動き回る姿や、普段は見られない晩ご飯の様子を楽しめる。動物たちの〝夜の素顔〟をカメラでのぞいた。

実は夜行性

カバ

暗い水面から周囲をうかがうカバのモモコ。実は夜行性で昼間より格段に活発になり、プールに飛び込んだり、走り回ったりすることも。

73

○ 夏休み特集
夜の姿も魅力的

さすが鳥類

晩ご飯だよ

フンボルトペンギン

ライトで照らされた幻想的な雰囲気のプールを泳ぐフンボルトペンギン。窓から水中をのぞくと、大空を飛び回っているようで「さすが鳥類」と実感。

オタリア

夕暮れ近い午後7時は、オタリアの晩ご飯の時間。水面に顔を出して来園者から好物のアジをもらうが、50匹を瞬く間にたいらげてしまった。

家族だんらん

夜間開園中の熊本市動植物園の園内。親子連れやカップルが楽しそうに散策していた。

シシオザル

午後8時すぎ、シシオザルは家族だんらんの時間。日没後はガラス面の反射が無くなり、日中より観察しやすくなる。

Part.3

鳴き声で
気持ち分かる

モルモット
齧歯目テンジクネズミ科
分布 南米
体長 20～40cm
体重 1～1.5kg

Q&A

次の3つの鳴き声の時のモルモットの気持ちは？

（1）ピープィー
（2）キーキー
（3）キューイーキューイー

答え：飼育員の西佑莉江さん(20)によると、(1)はうれしい時。(2)は嫌だやめて！(3)は大好物のタンポポの葉っぱをもらったり、何か期待している時。他に怒った時はカチカチと歯を鳴らすそうだ。熊本市動植物園は47匹を飼育。タッチ愛ランドで触れ合うことができる。

午前中だけ活発

フクロウ

フクロウ目フクロウ科
分布 ユーラシア大陸北部
体長 50〜62cm
体重 500〜1300g

餌の冷凍ネズミを足でつかんで、飼育舎を飛び回るフクちゃん（性別不明、3歳）。来園者に"獲物"を見せびらかすように、すぐには食べない。山都町の山林で幼鳥時に保護され、県鳥獣保護センター（御船町）に持ち込まれた。飛べるようになり放鳥したが、何度も戻ってくるため、2013年に熊本市動植物園に預けられた。飼育員の山部哲也さん（44）は「朝の食事が済むと閉園までほとんど昼寝タイム。午前中の活発な姿を見てほしい」と話していた。

「臭くないよ」

クサガメ

カメ目ヌマガメ科
分布 日本など
体長 15〜30cm
体重 250〜500g

親ガメの後ろにくっつく10センチ弱の子ガメ。1歳直前の5月にデビューした。熊本市動植物園には、14匹（性別不明）がいる。漢字で書くと「臭亀」。外敵から身を守るため、臭い分泌物を出すから付けられたらしい。見た目がかわいいだけに気の毒な気がするが、「うちのカメは臭くありませんので、ご安心を」と飼育員の林修司さん（54）。6月中旬に卵十数個が確認されていたが、早朝、カラスに食べられてしまう"事件"が発生。飼育員らは再発防止に躍起だ。

激減する日本固有種

ニホンイシガメ

カメ目ヌマガメ科
分布 日本
体長 14〜22cm
体重 700〜900g

クサガメの記事に、中学1年生から「イシガメじゃないか」と電話があった。クサガメは甲羅に3本の山線、小さい頃は顔に黄線の模様もある。イシガメは山線は1本で顔の模様はない。紹介したクサガメは、山線は3本だが、顔の模様はなし。熊本市動植物園に調べてもらうと、「どちらの特徴も持つ交雑種のようだ」とのこと。こちらは正真正銘のイシガメ。日本固有種だが生息数は激減し、準絶滅危惧種。顔は愛嬌たっぷりで「ワニやニシキヘビにも負けない人気者」と飼育員の小川誉夫さん(46)。

園内で飼育員が捕獲

シマヘビ
有鱗目ナミヘビ科
 ゆうりん
分布 日本
体長 90〜160cm
体重（1mで）約250g

目玉が赤く、体表に4本の縦じまが通る。警戒心が強く、尻尾を地面にたたきつけ、バタバタバタと音を出して威嚇する。気性は荒いが、無毒。熊本市動植物園では性別不明の1匹を飼育。4月、園内の池を泳いでいるのを、飼育員の福本綾香さん(27)が見つけて網で捕獲し、餌づけして展示を始めた。日本では一番身近なヘビの一種。体表が黒化したものはカラスヘビとも呼ばれる。「この個体は、顎の下にきれいな黄色が浮かび上がって美形です」と福本さんは愛着たっぷり。

相良村の生息地再現

ニホンザル

霊長目オナガザル科
分布 日本
体長 50〜70cm
体重 8〜18kg

熊本市動植物園は2013年、コンクリートの猿山を取り壊し、先祖が暮らした相良村の生息地を再現。オス3匹、メス9匹が暮らし、農家の納屋風の建物内部から、段々畑などを闊歩(かっぽ)する姿を間近でのぞける。ガラス越しに数センチの距離まで近づくと、窓に唇を押しつけ、子猿が"変顔"を披露してくれた。隣の母親は、「よしなさい」とたしなめているのか。水場で餌を洗ったり、行水する姿も。「コンクリートの猿山時代より伸び伸びしていて、毛並みも良くなった」と飼育員の長井和樹さん（32）。

虹のように輝く羽

ニジキジ

キジ目キジ科
分布 ヒマラヤ地方
体長 60〜70cm
体重 1800〜2500g

西日を浴びたオスは、名前の通り、羽を虹のように輝かせていた。冠羽もおしゃれ。最も美しいキジといわれ、クジャクと間違われることも多い。熊本市動植物園ではオス1羽とメス2羽を飼育。暑さが苦手なため、夏場は、ミストシャワーが設置される。シャワーが始まると、目をつぶって、うっとりとした表情を見せる。飼育員の松村公子さん（33）は「メスは地味だけど、目の周りにアイシャドーのような水色の模様があり色気があるんです」。

けがで飛べず保護

ハヤブサ

ワシタカ目ハヤブサ科
分布 ほぼ全世界
体長 38〜51cm
体重 500〜1300g

名前は「ペル」(性別不明)。熊本市出身の漫画家・尾田栄一郎さんの代表作「ワンピース」のキャラクターから名付けられた。好物の肉をついばむ姿はまさに猛禽(もうきん)だが、意外につぶらな瞳は愛らしい。2011年に北九州市の山林で左肩付近を骨折し飛べなくなったため保護された。展示場は熊本市動植物園の一番端。飛べないので地上にいることが多く、気付かない来園者も多い。「懸命に生きている姿を見てほしい」と飼育員の山部哲也さん(44)。
※2015年8月死す

意外と憶病な性格

ニホンスッポン

カメ目スッポン科
分布 日本など
最大直径 約40cm
体重（直径約20cmで）約1kg

熊本市動植物園では3匹を飼育。動物資料館の屋外池には直径40センチ、6.5キロの"大物"もいて、時折顔をのぞかせては、来場者を驚かせる。他のカメ類と異なり、甲羅は角質化せず柔らかいまま。冬眠明けは、甲羅にろっ骨が浮いて見えるほどやせ細っているという。飼育員の福本綾香さん（27）は「『かみつかれたら雷が鳴っても離れない』と怖がられるが、憶病な性格で、引っ張ったりせず、やさしく水に浸けると逃げていく」と教えてくれた。

しま模様で
つながる母子

グラントシマウマ
奇蹄目ウマ科
分布 南アフリカ南部
体長 2〜2.4m
体重 220〜270kg

なぜ、しま模様なのかは諸説あるが、サバンナで集団移動すると、敵から1頭1頭を特定されにくくなる、という説が有名。ちなみに地肌は灰色だ。母親のミヤコ（11歳）に隠れて長男のカイセイ（1歳）がカメラをのぞき込んだ。生まれた時から全身に白黒の毛が生えており、母親のしま模様とすっかり同化している。熊本市動植物園では父親カケル（16歳）と長女ヒトミ（2歳）の計4頭を飼育。「母親は父親を息子に近づかせない」と飼育員の戸田広幸さん（50）。しま模様でつながる母子愛を見守る。

実は「しゃべりません」

アカコンゴウインコ

オウム目インコ科
分布 メキシコなど
体長 80～95cm
体重 約1kg

全身深紅で、羽と尾の青と黄色のラインが鮮やか。オウムの代表格の存在だからか、来園者もしゃべるかどうかが気になる。だが、飼育員の中島伸明さん（50）は「飼育舎の前で、よくオハヨーとかコンニチハとか声をかけていらっしゃいますが、残念ながらしゃべりません」と打ち明ける。鳴き声はギャーっと大きい。熊本市動植物園では2羽（年齢・性別不明）を飼育。1羽は1974年来園と同園での飼育は41年目。もう1羽も20年。脚を器用に使い、好物のグレープフルーツを食べる姿はワイルド。

暗がりに浮かぶ角

シバヤギ
偶蹄目ウシ科
日本在来種の家畜
体長 約80cm
体重 20〜30kg

全身まっ白の毛で愛らしいイメージのオスの「トラちゃん」(7歳)。飼育舎裏にある観察窓からのぞき込むと、暗い室内に差し込むかすかな光が、横顔のシルエットと彫刻のように立派な角を浮かび上がらせていた。熊本市動植物園ではメス8匹の中に"黒一点"で暮らす。「トラちゃんだけは、名前を呼ぶと、角でドアノブを押して展示場に出てくる」と飼育員の一安裕子さん(35)。歴代のオスと違い、人を攻撃したことがない温厚さ。暗がりで名前を呼ばれるのを、じっと待っていたのだろうか。

原種の展示は国内唯一

天草大王
キジ目キジ科
分布 熊本県
オス最大体長 90cm
体重 6.7kg

幼児ほどの大きさがある日本最大のニワトリ。まさに"大王"の風格だ。昭和初期に絶滅したが、県が2001年に復元させた。肥後五鶏の1つ。熊本市動植物園ではオス、メス1羽ずつを飼育。原種の展示は国内でも同園だけという。食肉用として流通する「天草大王」は、原種のオスと、専用に開発された品種「九州ロード」のメスを掛け合わせたもの。原種は県農業研究センターが一元管理。「園では卵が生まれても、ふ化させてはいけないという決まり」と飼育員の松本充史さん（43）。

"美人"見分けは 首の羽

インドクジャク

キジ目キジ科
分布 インド
体長 90〜130cm
体重 3〜6kg

　4月から7月末の繁殖期にだけ、オスは極彩色の美しい羽を広げメスを魅了する。夏場を過ぎると羽は抜け落ち、メス同様、褐色の地味な姿になる。熊本市動植物園では、合計40羽を飼育。2015年は5羽を園内の動物管理センターで人工ふ化させた。特定のペアは作らず、いわば多夫多妻制だという。飼育員の長野祐太さん（29）は「オスはメスの首の後ろの羽をくわえてペアリングする。首の羽が抜けているのは美人の証拠」と教えてくれた。

鉄柵に体ゴシゴシ

ウマグマ

食肉目クマ科
分布 中国など
体長 150〜160cm
体重 200〜300kg

「チョー気持ちいい」とばかりに、鉄柵に頭や体をゴシゴシとこすり付ける癖がある熊本市動植物園のコジロー（オス、推定31歳）。「季節を問わず毎日数回。他のクマでは見たことがない」と飼育員の西村光輝さん（57）。はっきりとした理由は分からない。フサフサの毛が特徴で、暑さは大の苦手。毎年9月までに冬毛が抜け落ちて"夏痩せ"するが、暑い日はプールに氷を入れるなどの熱中症対策が欠かせない。「おやつの冷凍ミカンが大好物です」と西村さん。

ガラスこする4本爪

ヨツユビリクガメ

カメ目リクガメ科
分布 中東アジアなど
体長 最大約30cm
体重 約1.5kg

名前の由来となっている4本指で、飼育室のガラスをこすりながら、カメラのレンズをのぞき込んできた。「あっち行け」と言われているのか、ガラスをきれいにして歓迎してくれているのか？ 熊本市動植物園では性別不明の1匹を飼育。主に砂漠などにすみ、モグラのように穴を掘るのが得意。深さ1メートル、広さ3メートルほどの巣を作るという。寿命は30～50年。飼育員の鎌田絵美さん（25）は「室温が15度を下回る11～5月は、暖房のある別室に移して、体力が消耗する冬眠をさせないようにしています」。

並んだオレンジの瞳

ワオキツネザル

霊長目キツネザル科
分布:マダガスカル南部
体長 35〜45cm
体重 2.3〜3.5kg

オレンジ色の大小4つの瞳が並ぶ。親子の顔はそっくりだ。熊本市動植物園では、開放型展示施設「モンキーアイランド」で、オス3匹とメス4匹を飼育。2015年は2匹の赤ちゃん(性別不明)が誕生した。寒さが苦手で、皆で体を寄せ合い暖をとる。仲の良さが伝わってくるのだが、飼育員の山部哲也さん(44)には心配事がある。「園育ちの14歳のオス長老が今春から展示場に出なくなり、1匹で寝室に引きこもっている。けがやいじめが原因ではなさそうなのですが」

3カ月で親離れ

ボリビアリスザル

霊長目オマキザル科
分布 コスタリカなど
体長 25〜30cm
体重 370g〜1.1kg

9月上旬、カメラを向けると、母親の背中にしがみついた赤ちゃんに見詰められた。「かわいい」。思わずつぶやいた。生後約1カ月で、体長は15センチほど。名前はまだない。熊本市動植物園には、14匹（オス5、メス6、不明3）がいる。この赤ちゃんだけでなく体が小さいので性別が判定しにくいという。「8月9日に生まれました。3カ月ほどで親離れします」と飼育員の的場秀嗣さん(51)。間もなく見納めになると思うと、ちょっぴり残念だ。

オスを探せ

アメリカオシ

ガンカモ目ガンカモ科
分布 北アメリカなど
体長 40〜45cm
体重 500〜600g

Q&A

上の写真の中にオスが1羽います。どれでしょう？

答え：右手前の1羽。目玉が赤いのがオスだ。4月から6月の繁殖期には、オスは頭部が緑色に彩られ、派手だが、繁殖期が終わるとメスと区別が付きにくい地味な姿になる。右の写真が繁殖期のオス。熊本市動植物園ではオス4羽、メス8羽を飼育。飼育員の久保英明さん（55）は「園内ではオスとメスの比率が違うからか、"一夫二妻"のペアを作っている」と話していた。

鋭い舌、
くちばしと同じ

タンチョウ

ツル目ツル科
分布 日本など
体長 120〜150cm
体重 6〜9kg

時折、鳴き声とともに大きく口が開き、細長い舌が見えた。くちばし同様の鋭い形に驚く。舌には体温調節の役目もある。熊本市動植物園ではオス（31歳）とメス（8歳）を飼育。2015年4〜6月に計5個の卵を産んだ。来園者通路のすぐ近くにヨシの茎で巣作りし、互いに交代しながら約3カ月間抱卵を続けたが、一つもふ化しなかった。ペアになって2年目。卵は今春が初めてだった。飼育員の山部哲也さん（44）は「23歳の年の差婚を乗り越えて、来年は元気なヒナを見せてほしい」と願った。

好奇心旺盛な人気者

ホッキョクグマ
食肉目クマ科
分布 北極圏
体長 180～250cm
体重 200～600kg

カメラに興味を持ったのか？ 熊本市動植物園のマルル（メス、2歳）が、プール脇の窓から、しげしげとのぞき込んできた。開園以来の人気者だったホッキョクグマだが、先代のミッキーが2012年に28歳で死んで、1年半は姿が消えていた。待望のマルルは14年3月、札幌市円山動物園から2年契約で来園。かわいいからと、食べ物を投げ入れる来園者もいるそうだが、「自然本来の姿を失うので、絶対にやめて」と飼育員の伊藤礼一さん（49）。

仮面は
真っ赤なハート

ミヤマハッカン

キジ目キジ科
分布 ネパールなど
体長 70〜130cm
体重 約0.7〜1.5kg

以前紹介したメンフクロウの顔も白いハート形だったが、こちらは情熱的な真っ赤なハートの仮面を着けているようだ。2〜6月の繁殖期には、赤がより鮮やかさを増す。熊本市動植物園ではオス2羽を飼育。やんちゃな性格で、少しもじっとしていない。止まり木の上から突然、飼育員の頭に飛びかかるいたずらもする。ハワイのボルケーノ国立公園では狩猟用として1960年代に持ち込まれたものが帰化しているという。

得意技は穴掘り

ベニコンゴウインコ

オウム目インコ科
分布 南アメリカ北部
体長 80〜95cm
体重 約1kg

他のインコ類とは違い、地面に降りて歩き回る。土に穴を掘るのも得意で、巣箱の下に地下室を作って隠れ家にしていたが、6月末に飼育員に見つかり、ベニヤ板で入り口をふさがれてしまった。熊本市動植物園では、性別不明で名前のない1羽を飼育。くちばしが強力で、木製のえさ台はかじられないように、プラスチックで補強されている。飼育員の中島伸明さん(50)は「いつもえさ箱に直径2センチほどの石ころが入っている。地面から拾い上げているようだが、理由は謎です」。

煮干し
おいしい！

プレーリードッグ
齧歯目リス科
分布 北アメリカ中央部
体長 30〜40cm
体重 500〜1000g

「君たちまだ子どもだねー。僕は煮干しが一番さ」。そんな会話が聞こえてきそう。左の1匹だけ、煮干しを握りしめてムシャムシャ。熊本市動植物園では、オス4匹とメス7匹を飼育している。毎朝、食事の時間は全員総立ち。「煮イモが一番人気。口に詰め込んでから、それぞれの好物を味わう」と飼育員の古屋千尋さん（26）。6月には飼育場の木製の壁をかじって穴を開け、園内に集団脱走。飼育員が網を持って必死で捕獲したという。

寂しげな遠ぼえ

ライオン

食肉目ネコ科
分布 アフリカ
体長 240〜330cm
体重 120〜250kg

昼寝から目覚めた熊本市動植物園のリボイ(メス、12歳)が、口で顔が隠れるほどの大あくび。10回以上の出産経験がある"肝っ玉母ちゃん"で、同園でも3頭産んでいる。だが子どもは園外に行き、約5年連れ添ったオスのセボシも昨年、16歳で死んでしまった。今は1頭だけで暮らす。夕方になると「ヴォ、ヴォ、ヴォ」と遠ぼえが園内に響く。サバンナなら2〜3キロ先まで届く大音量。飼育員の伊藤礼一さん(49)は「どこか寂しげな声なんです」。11月には新しくオスが来園予定だが、リボイはまだ知らない。

若き"百獣の王"見参
「サン」2015年12月11日から公開

熊本市動植物園は12月9日、ライオンのオス「サン」(7歳)が大分県の九州自然動物公園から来園し、11日から一般公開すると発表した。ライオンはサハラ砂漠以南のアフリカ大陸に生息し、絶滅危惧Ⅱ類に指定されている。市動植物園では2014年10月にオスのセボシが死亡。ライオンはメスのリボイ(13歳)だけとなっていた。サンは体長140センチで推定体重190キロ。11日は午前10時から午後1時まで公開の予定。当面の間はリボイと交代での公開となる。9日午後は、展示スペースの環境に慣れるための訓練を実施。飼育員が「サン、サン」と声を掛けたり、馬肉で誘ったりしていた。初めは警戒していたが、徐々に慣れて動き回りだした。松崎正吉園長は「園待望の若くて元気のいいオスのライオン。これぞ百獣の王という貫禄を見に来てほしい」と話した。

子どもに大人気

ウサギ

ウサギ目ウサギ科
家畜種
体長 約30cm
体重（小型種）1～2kg

「遊んでほしいときには寄ってくるけど、自分勝手で気分屋。性格はネコに似ていると思う」と飼育員の今村桂子さん（31）。熊本市動植物園では、ダッチ1匹、レッキス1匹、ミニウサギ2匹、ホーランドロップイヤー7匹の計11匹を飼育。普段はガラス越しにしか観察できないが、園内のイベント「わくわく動物ガイド」では触れ合うことができ、子どもたちに大人気だ。気に入らないことがあると、後ろ脚を地面に打ち付けながら、「グッ」と鳴いて怒るのでご用心。

夏休み特集

アップで見たな〜!!

連載「素顔の動物園」の今回は、未掲載写真から選んだ「クローズアップ」編。熊本市動植物園の動物たちに超望遠や接写レンズで思い切り迫ってみると、普段は気付かない"別の素顔"が見えてくる。

おいしい！

クロクモザル

夕方、寝室に戻って食事をするクロクモザル。窓ガラス1枚を隔てた数センチの距離で観察できるが、青い目で見詰められてドッキリ。

夏休み特集
アップで見たな〜!!

触ってみたい

アムールトラ
寝そべったアムールトラの足の裏には立派な肉球。怖いけど、触ってみたくなる。

大あくび

カバ
飼育員に午後のおやつをもらうカバ。近くにいた子どもが「大きなあくび」と目を丸くした。下のキバはきれいにカットされている。

わたしは誰？

カピバラ
カメラにぐいっと顔を近づけてきたカピバラ。誰か分からないほど大写しになった鼻に吸い込まれそう。

マンドリル
カラフルな顔に目を奪われるオスのマンドリルだが、後ろ姿は"モヒカンヘア"。決まってる？

モヒカンヘア

夏休み特集
アップで見たな〜!!

ニヤリ

メガネカイマン

薄暗い部屋の中で目を光らせるワニのメガネカイマン。
白い牙が並ぶ口元が、ニヤリと笑みを浮かべているよう。

110

肥後ちゃぼの魅力知って

世界一のとさか 芸術的な美しさ

巨大なとさかのニワトリ「肥後ちゃぼ」。県内で脈々と受け継がれてきたものの、鳥インフルエンザを機に飼育環境が厳しさを増すなど逆風もある。愛好者団体「肥後ちゃぼ保存会」（松崎正治会長）は、ひな鳥を希望者にレンタルする新たな試みも始め、魅力のアピールに懸命だ。

熊本市動植物園は、肥後ちゃぼを含む肥後五鶏の展示施設を2005年に開設。ニワトリの展示は全国の動物園でも異例だ。肥後ちゃぼには「世界一のとさか」と解説がある。

5月中旬、同園であった恒例の「肥後ちゃぼ展」。ひなとの触れ合いを楽しむ親子に、保存会の会員が声を掛けた。「レンタルで育ててみませんか？」

レンタル飼育は3カ月間、ひなと一緒に、

111

キジ目キジ科
分布・日本
標準体重 オス870g、メス670g
大冠桂（たいかんかつら）と達磨（だるま）の2種類がいる。一般的なニワトリより小さめだが、とさか先端から肉垂（にくすい）までの長さはオス18〜20cm、メス9〜10cm。熊本市動植物園では大冠桂のみ5羽を飼育。久連子鶏、薩摩鶏とともに九州三大珍鶏とされる。

「達磨」のオス（左）とメス

保存会、
ひな貸し出しも

「レンタルひよこ」の張り紙の前で、肥後ちゃぼのひなをさわる子どもたち＝熊本市動植物園

　用具も無償で貸し出す。以降は、ワクチン接種などが必要なため、「ピヨピヨからコッコと鳴き始める」飼育が容易な間だけ、楽しんでもらう試みだ。期間終了後は保存会に返却してもらう。

　2013年にスタートし、これまで22組約60羽をレンタル。別れを惜しみ泣きだす子もいたという。保存会に入会し、ワクチン接種すれば、そのまま飼うこともでき、2組が飼育を続けた。

　チャボは1941年、国天然記念物に指定。全国から姿を消す中、熊本で「大冠桂」と「達磨」の2種が見つかり、1968年、総称「肥後ちゃぼ」と命名され、保存会も同時に発足した。78年からは県養鶏試験場（現農業研究センター）でふ化委託をスタートし、飼育数・者ともに順調に増加した。

　しかし96年末、鹿児島県内で鳥インフルエンザが発生。防疫強化のため同試験場でのふ化委託が終了する事態となった。さらに7年後には大分県でチャボが感染した。

　この影響で保存会が小学校などにひなを寄贈して地道に増やした飼育団体数も20から13まで減少し、99年に147人だった会員は2008年には65人と半数以下に落ち込んだ。

　ところが近年、インターネットなどで肥後ちゃぼを知った県外からの問い合わせが増加。県外から26人が入会し、会員数は93人（2014年）まで回復した。コンテストで高校生が優勝し、若手の発案でレンタル飼育が始まるなど、新世代の活躍も目立っている。

　「肥後ちゃぼは芸術的な美しさが最大の魅力。大切な熊本の伝統文化として後世に伝えていきたい」と今村安孝副会長（57）は力を込めた。

Part.4

水中を羽ばたく

フンボルトペンギン

ペンギン目ペンギン科
分布 南アメリカ南部
体長 55〜70cm
体重 3.5〜6kg

大空を羽ばたくように水中を自在に泳ぐ姿に、子どもたちもくぎ付け。2013年にリニューアルしたペンギン舎は、水族館のように水槽の一部が透明になっていて、間近で観察できる。熊本市動植物園では、計22羽を飼育している。飼育員の中島誠一さん（53）は6月末の早朝、生後3カ月の赤ちゃんが嘔吐・痙攣しているのに気づいた。抱きかかえると、苦しくて涙を流しているように見え、自分も涙が出た。懸命の看病で回復した1羽とは、「いつでも私の後をついてくる」と自慢するほど深い絆が生まれた。

はしごも へっちゃら

アライグマ

食肉目アライグマ科
分布 アメリカなど
体長 40～60cm
体重 5～15kg

「よっこらしょっ」と、はしごを登るオスのガイ（15歳）。タヌキとよく間違われるが、しっぽが太く黒いしま模様がある。指1本1本も長い。熊本市動植物園では兄弟2匹を飼育。弟のリュウ（オス、14歳）と仲良く暮らしていたが、4年前からけんかするようになり、現在は別居中。足に擦り寄ってくるほど人慣れしている。だが、輸入ペットが野生化して県内でも問題になっている。「顔はかわいいが、爪と牙は鋭い。山などで見掛けても近づかないで」と飼育員の西村光輝さん（57）。

届かない視線

ハッカン

キジ目キジ科
分布 中国南部など
体長 50 〜 130cm
体重 700 〜 1500g

赤い目で、オス（左）にアイコンタクトを送るメス。しかしオスは首をかしげたまま、素っ気ない。実は右目が見えず、メスの視線に気付いていないらしい。熊本市動植物園ではオス、メス各1羽を飼育。高齢になったオスは、白内障で片目の視力を失っている。飼育員の立山三徳さん（52）は「オスが若かった10年前は、餌やりの時にヘルメットをしなければならないほど攻撃的だったんですよ」と、長年の付き合いを懐かしんだ。

鶏の祖先に最も近く

セキショクヤケイ

キジ目キジ科
分布 東南アジアなど
体長 50～60cm
体重 1～2kg

鶏の祖先に一番近い。犬に例えるとオオカミ。オスはテリトリー意識が強く攻撃的で、飼育員の長靴に蹴爪(けづめ)で穴を開けるほど。熊本市動植物園ではオス4羽、メス12羽を飼育。オス1羽にメス3羽が1グループになり、四つの部屋に分かれて暮らす。夜は樹上で寝る。同じ鶏でも、肥後五鶏はミミズを食べないが、この種は大好物。「どんなに大きくても、ツルツルと丸飲みしてワイルドですよ」と飼育員の八代梓さん(24)。

派手顔の奥の
優しい瞳

マンドリル

霊長目オナガザル科
分布 アフリカ西部
体長 50〜80cm
体重 10〜30kg

真っ赤な鼻筋、青いひだのある頬…歌舞伎の隈取りをしたような派手顔のコタロウ（オス、19歳）だが、その奥にある瞳の優しさに気づく人はあまりいない。熊本市動植物園は穂奈美（メス、23歳）とともに2匹を飼育。見学者に顔を近づけ、犬歯を見せた後、尻を突き出すことがある。威嚇しているように見えて、実は"あいさつ"だとか。「穂奈美は白内障で目が見えず餌も手探り。聴覚だけが頼りなので、驚かさないで」。飼育員の的場秀嗣さん（51）が2匹を見つめる瞳もまた優しい。

「あ〜ぁ、あ〜ぁ」と残念がる人間のような鳴き声が響いた。声の主は閉園間近の夕暮れ時に、丹念に毛づくろいしていた。熊本市動植物園では性別不明の4羽を飼育。2014年に特定外来生物に指定されたため、園内で放し飼いができなくなり、囲いの中で暮らす。繁殖させることもできないので、この4羽が園での最後の飼育となる。「菜の花の季節には、植物園ゾーンに出掛けて花芽を食べ歩く人気者だったんですが」と飼育員の長野祐太さん(29)。独特の鳴き声が、本当に残念そうに聞こえた。

残念そうな鳴き声

カナダガン
ガンカモ目ガンカモ科
分布 カナダなど
体長 約70cm
体重 2.5〜6.5kg

"俺さま"なオス

オナガキジ

キジ目キジ科
分布 中国東北部
体長(尾羽含む) 75～200cm
体重 1～1.5kg

「あなた、行かないで〜」とばかりに、オスの立派な尾羽を思いっきり踏み付けたメス。オスは気にするそぶりも見せない。飼育員の一安裕子さん(35)は「他のキジ類は、餌をメスにプレゼントするなど紳士的だが、このオスは全部自分だけで食べてしまう」と、オスの"俺さま"ぶりを教えてくれた。熊本市動植物園ではオス1羽とメス3羽を飼育。オスは繁殖期が終わると尾羽が抜け落ち"尾長"ではなくなるのだが、約2カ月で再生する。

体重測定、
危険でできず

アフリカニシキヘビ

有鱗目ボア科
分布 アフリカ
体長 3〜7m
体重 不明

アフリカ最大のヘビ。とぐろを巻き、舌をペロッ。茶褐色の巨体を独特の模様が彩る。熊本市動植物園には1匹(性別不明・約10歳)がいる。2012年の7月に鹿児島県の平川動物園から来園した時は体長1.7メートルだったが、今は3メートルに。体重測定は危険で行えていない。「怖いので必ず2人で作業をします。だってシュ〜って鳴くんですよ」と飼育員の本田信夫さん(46)もびくびく。同年4月に死んだ先代のアミメニシキヘビ(24年9カ月飼育・年齢不明)は、5.7メートルで47キロあった。

おしとやかな
レディー

シロビタイムジオウム

オウム目オウム科
分布 オーストラリアなど
体長 約32cm
体重 約400g

パプアニューギニア館のガラス窓から、つぶらな瞳でこちらをのぞき込むのは、メスのタイちゃん。熊本市動植物園では、つがいの2羽を飼育。一緒の展示場に入れていたら、お互いに毛づくろいし過ぎて、羽が抜け落ちてしまった。羽が生えそろうまでの期間、オスは園内の動物管理センターで別居中。オスは『ソラちゃん』と自分の名前をしゃべって自己アピールするタイプだが、「タイちゃんは、鳴き声を聞いたことがない。おしとやかなレディー」と飼育員の林修司さん（53）の評。

コイにエサ分け与え

コクチョウ

ガンカモ目ガンカモ科
分布 オーストラリアなど
体長 110～140cm
体重 5～9kg

「コイさんも、お食事の時間ですよ」。口にくわえた自分たちの餌を、まるでわが子のように、池のコイに分け与えるペア。熊本市動植物園には、オス3羽とメス4羽がいるが、個体数を抑制するため、卵ができても撤去してしまう。「ヒナができないので、コイの面倒を見ているのでは」と飼育員の長野祐太さん（29）。卵を奪われまいと、親鳥は大きな羽で必死に防御。羽の力は強力で、はたかれると長靴の上からでもあざができるほどだという。

人懐っこく寄ってくる

ミミナガヤギ
偶蹄目ウシ科
　ぐうてい
家畜種
体長 90〜100cm
体重 25〜60kg

体温調整に役立つ30センチを超える耳を垂らし、3月に生まれた息子スカイに寄り添うのは、母親のイング（4歳）。熊本市動植物園には、オス3匹とメス3匹がいるが、4年ぶりに生まれた待望の子どもがスカイだ。母親のイングは小さい時に母親から耳をかまれ、左耳だけ短い。飼育員の立山三徳さん（53）は「つらい体験だったろうが、自分の子どもは立派に育てている」と目を細める。メスにも長くねじれた角がある上、黒っぽい顔立ち。ふれあい広場で怖がられることもあるが、実は人懐っこくて、触ってほしくて近寄ってくる。

大みそかは親子で…

シフゾウ
偶蹄目シカ科
分布 野生では絶滅
体長 180〜220cm
体重 150〜210kg

「ひづめは牛、頭は馬、尾はロバ、角はシカ」だが、そのどれでもない中国原産の珍獣。野生では19世紀末に絶滅した。熊本市動植物園には5頭いるが、他は多摩（東京・4頭）と安佐（広島・2頭）の2園で飼育されるのみ。2歳のチョッパー（オス）にカメラを向けると、4つの特徴が一目で分かるポーズを決めた。父親は大みそかに角が落ちることで知られるジロー（16歳）。「ことしの大みそかは親子そろって角が落ちないかな」と飼育員の森田聡さん（45）。

"にらみ"効かせ鬼退治!?

ニホンキジ

キジ目キジ科
分布 日本
体長 60〜80cm
体重 600〜1100g

おとぎ話の桃太郎は、なぜ鬼ヶ島へイヌ、サルと共に、戦力にならなそうなキジを連れていったのか。顔をまじまじと見たら、疑問が解けた気がした。赤い隈取りのある眼光はにらみが効いて、とても強そうなのだ。熊本市動植物園では、つがい1組を飼育。日本固有種の国鳥で、1万円札にも描かれている。見た目と違い、掃除中の飼育員を攻撃することもなく、キジ類の中でもおとなしい。「思慮深さを感じるたたずまいは、武士や忍者のようだ」と飼育員の立山三徳さん(53)。

感情表す耳の向き

ポニー

奇蹄目ウマ科
家畜種
体高 147cm 以下
体重 140 〜 250kg

「この子たちは、耳の向きで感情が分かるんです」と動物園勤務歴32年の古谷光昭さん（61）。後ろ向きは「怒り」、左右に振ると「警戒」、前に向いていれば「平穏」なのだそうだ。肩までの高さは147センチ以下。熊本市動植物園では、1997年に姉妹都市の福井市から寄贈されたヤヨイ（メス、24歳）とエレガンスター（オス、21歳）の2頭を飼育している。夏毛に生え替わる5〜7月は、毛玉のカットとブラッシングが欠かせない。美しい毛並みは、飼育員の努力のたまものでもある。

探すのに一苦労

ルーセットフルーツコウモリ
翼手目オオコウモリ科
分布 タイなど
体長 9.5～18cm
体重 45～106g

「どこにいるの？」と、来園者も姿を探すのに一苦労。目を凝らすと、薄暗い室内で天井の1カ所に固まり、ぶら下がっているのが分かる。リスみたいな目が愛らしい。熊本市動植物園ではパプアニューギニア館で4匹（オス・メス不明）を飼育。姿を見たいなら午前中の照明が付いている時間帯が狙い目。午後は真っ暗で見つけるのは難しい。名前の通りフルーツが大好物。「餌が翌朝にはなくなるので飛び回っているはずだが、展示中に飛ぶ姿は私も見たことがない」と飼育員の林修司さん（54）。

愛らしい鳴き声

ナナクサインコ

オウム目インコ科
分布 オーストラリア
体長 29～33cm
体重 100～125g

赤、黄、青、緑…思い付くままに原色をまとったのではないかと思えるほどのカラフルな羽色。熱心に毛づくろいする姿は、「きれいでしょ」と見せびらかしているようでもあり、「あー悔しい」と袖をかんでいるようにも見える。ペットとしても人気があるが、熊本市動植物園では、1つがいを飼育。雌雄はほぼ同色で、「ピッピッピ」と愛らしい鳴き声を響かせる。飼育員の本田信夫さん(46)は「鳴き声を聞くと、掃除中も森の中にいる気分になれます」と、"癒やし系"の担当がお気に入りの様子だった。

ピンクのくちばし

ツクシガモ

カモ目カモ科
分布 ヨーロッパ北部など
体長 55〜65cm
体重 0.6〜1.3kg

日本へは冬鳥として九州北部に飛来するため、「筑紫鴨」という和名が付いた。オスメス同色で、ピンク色のくちばしがチャームポイント。熊本市動植物園はメス2羽だけだったが、10月にオス、メス各1羽が高知県からやって来た。オシドリ（10羽）と同じスペースなので、遠慮がちに隅っこにいる姿が目につく。「メス2羽の時はオシドリの卵を温めることもあったが、ようやくオスを迎えて自分たちの卵を温められそう」と飼育員の長野祐太さん（30）。

新ボスへ猛アピール

ニホンジカ
偶蹄目シカ科
分布 日本
体長 100〜170cm
体重 40〜100kg

「キュー、ベー」と大きな鳴き声が響く。秋から冬の発情期に入り、ボス争いが始まったのだという。飼育員の中村寿徳さん(52)が「序列3位のオスが新ボスになりつつあり、アピール中」と教えてくれた。争いを予見して、相手にけがを負わせる角はカットされているものの、頭をぶつけて力を誇示し合う。県内では森林や農作物の食害が問題化し、厄介者の一面もあるが、奈良県の春日大社では「神の使い」として大切にされており、奈良公園にいるニホンジカは国の天然記念物。

五家荘で飼われた"地鶏"

クレコドリ

キジ目キジ科
分布 熊本県
体長 約45cm
体重 2.5～3kg

平家落人伝説で知られる五家荘（八代市）の久連子(くれこ)地域に伝わる古代踊りは、この鶏の長く黒い尾羽で顔も隠すほどに飾った花笠(かさ)を被(かぶ)り舞う。1つの花笠に、300～500本の羽が必要なため、300年以上、"地鶏"として飼われてきた。県の天然記念物で、肥後五鶏。熊本市動植物園ではオス1羽、メス2羽を飼育。地元や愛好団体の肥後ちゃぼ保存会と連携して、種の保存・繁殖に努めてきた。オスが首をブルンと振ると、首回りの銀笹色の羽が、古代踊りのように孤を描いた。花笠の尾羽に負けない美しさだ。

逃げ回るのが得意

エジプトガン

カモ目カモ科
分布 アフリカ大陸
体長 約70cm
体重 2.0〜2.5kg

やんちゃな性格で、食欲旺盛。カエルや虫まで何でも食べる。ペリカンと同居していた時は、餌の魚を素早く横取りしていた。だがアカツクシガモやインドクジャクと一緒の今は、みんなと餌が同じになり、横取りして逃げる必要もなくなった。どこか物足りなそうにも見える。熊本市動植物園では10羽を飼育。目の周りの茶色いドーナツ状の模様が特徴で覚えやすい。「本当に逃げ回るのが得意。水に潜られたら手に負えません」と飼育員の長野祐太さん（30）。

エサは1日100キロ

アフリカゾウ

長鼻目ゾウ科
分布 サハラ砂漠以南のアフリカ
体高 3～4m
体重 5～7t

右がマリー（35歳）で、左がエリ（34歳）。ともにメスだが、牙が長くて尻尾に毛がないのがマリー、牙が短くて尻尾の毛がふさふさなのがエリだ。アフリカゾウは九州では熊本市動植物園の2頭だけという。干し草や竹、野菜、牛乳、みそ汁など1頭で1日100キロを食べる。食事中もマリーが長い鼻をエリの口元に伸ばして、じゃれ合うが、それをいとおしそうに見守る飼育員の松本松男さん（49）は22年間、ゾウ担当。飼育舎を出るときは「行って来ます」、出勤時は「ただいま」と言うそうだ。

えと卒業「お疲れさま」

ヒツジ
偶 蹄目ウシ科
分布 世界中
体長 1.2〜1.5m
体重 45〜160kg

5月の毛刈りの時は、達観したように遠くを見つめる目が印象的だったが、年の瀬を迎え、随分と毛が伸びた。2015年はえとの動物としてふれあいイベントから写真展まで大活躍だった。「ことしは本当にお疲れさま」と飼育員の上野稚都恵さん(31)。熊本市動植物園では、コリデール種とサフォーク種のメス計3匹を飼育。1匹が移動すると習性でみんなついていくし、毛のフワフワ感も、とぼけたような表情も、よく見ると「かわいい」要素が盛りだくさん。まだまだサルに主役は譲れない？

美しい求愛ダンス

ホオジロカンムリヅル
ツル目ツル科
分布 アフリカ南部
体長 約1m
体重 3〜4kg

「鶴は千年、亀は万年」。長寿の縁起ものの鶴の中でも、金色の冠羽が一層めでたさを感じさせる。羽を広げた姿は豪華絢爛。多くの来園者が立ち止まって見とれてしまう。名前通り頬は白いが、繁殖期には赤くなる。熊本市動植物園では、ともに3歳になるオス、メスを飼育。2羽は千葉県から2015年4月に来園したが、メスは同園生まれ。古里で安心してか、8月と10月に卵を3個ずつ産んだが、ベビー誕生とはならなかった。「順調だったのに残念。ペアの求愛ダンスはとても美しいんですよ」と飼育員の山部哲也さん（45）。

吸い込まれそうな瞳

アムールトラ

食肉目ネコ科
分布 ロシアなど
体長 2.4〜3.3m
体重 100〜300kg

野生のトラは世界で約3200頭、最大種のアムールトラは400頭前後しかいないという。開発と密猟で、この100年で9割以上も生息域が減少した。熊本市動植物園のメスのチャチャ（5歳）は、国内で飼育される57頭のうちの貴重な1頭。2013年に来園し、馬肉を1日4キロも平らげ、1.8メートル、130キロまで成長した。超望遠レンズを向けると、瞳が吸い込まれそうなほどに美しい。国際血統登録され、世界中の動物園が協力して絶滅から守っている。

141

絶滅寸前から復活

クマモトシュ

キジ目キジ科
分布 熊本県
体長 オスで約50cm
体重 2.5〜3kg

カメラの前で、メスがオスにキスするようなしぐさ。オスの驚いたような顔も青春映画の1シーンみたいだ。「熊本種」の名前通り、明治後期から昭和初期にかけ、県内で多く飼われた地鶏。輸入品種に押され絶滅寸前だったが、県が1976年、山鹿市に唯一飼育されていた4羽から、近似種と交配を重ねるなどして復元に成功した。熊本種を大型改良した肉用の「熊本コーチン」が有名だ。熊本市動植物園ではオスメス各1羽を飼育。同園が毎年開く肥後五鶏講座では、天草大王との食べ比べもある。

金色の看板スター

キンシコウ

霊長目オナガザル科
分布 中国
体長 50〜80cm
体重 9〜20kg

金の糸をまとった猿「金糸猴」。午後の柔らかい日差しに金色の体毛を輝かせ、母親の盼々(ヘンヘン)（メス、24歳＝左）が、末娘の優優(ヨウヨウ)（メス、11歳）を毛づくろいしていた。熊本市動植物園には、この母子以外に、父親の宝々(バオバオ)（オス、26歳）と、同園生まれの星星(シンシン)（オス、18歳）、飛飛(フェイフェイ)（オス、16歳）の親子計5匹が暮らす。青い顔につぶらな瞳、ツンと上を向いた鼻…西遊記の孫悟空のモデルともいわれる。市制百周年記念事業として1989年に同園に別の2匹が3カ月限定で初来園。1993年から宝々が来園し、繁殖にも成功した。国内で飼育されているのは同園だけ。初来園時に飼育担当だった松崎正吉園長（59）は2016年3月、定年退職を迎える。「初来園時、メスが十数日後にようやく桃を半分だけ食べてくれた時の感動が忘れられない。すっかり熊本の看板スターになってくれた」と目を細めた。

番外編

命つなぐ園内の"病院"

動物管理センター　27種44匹を治療、保護
「ペットではない。野生の本能を保たせる」

クジャクの余生

2階建て延べ床面積670平方メートル。飼育部屋17室とケージ14区画があり、手術台やレントゲンも完備する。手術台では、職員の獣医師・上野明日香さん（36）が、インドクジャクを治療していた。高齢になり、左脚の関節炎で歩くのがままならなくなったという。炎症止めの注射を打ち、「餌の争奪戦に耐えられないので、再び群れに戻すことはできないが、長年、展示動物として貢献してもらった。ここでゆったり余生を過ごしてほしい」と温かく見守る。

熊本市動植物園の立ち入り禁止エリアにある「動物管理センター」は、園内の"病院"。治療や保護が必要な動物27種44匹が暮らしている。

右腕切断のサル

2015年7月生まれのボリビアリスザルのリピア（オス）は、生後間もなく右腕を裂傷。母親から引き離され、同センターで緊急手術を受けたが、右腕の切断を余儀なくされた。まだ離乳食を口にすることができなかったため、術後の2カ月間、飼育員らが毎日交代で家に連れ帰り、人間の赤ちゃん用のミルクを注射器で飲ませ、命をつないだ。今はすっかり元気。「情は移るが、ペットではない。野生の本能を保たせるのが重要だ」とも上野さんは言う。

密輸されたカメ

展示されない動物もいる。ワシントン条約で輸入が禁止されているインドホシガメは、密輸されたもの。保護した環境省からの依頼で、1997～98年に計79匹を受け入れた。気温変化に弱く、次々と死んだ。生き延びたのはわずか6匹。獣医師の松本充史さん（43）は「野生動物を生息地以外で飼う難しさを、密輸者は知っているのか」と憤る。人間の身勝手で密輸されたり、捨てられたりした動物が後を絶たない。同センターも満室状態で、今は園外からの受け入れは難しい状況だ。

番外編
命つなぐ園内の"病院"

145

ひび割れた園内の通路。奥は動物がいなくなった猛獣舎 4月30日

熊本地震
復興へ一歩一歩

2度の最大震度7を観測した熊本地震。震源に近い熊本市東部にある市動植物園も大きな被害を受け、長期休園を余儀なくされた。市は再開まで「1年以上かかる」との見通しを示している。

前震	2016年4月14日午後9時26分	マグニチュード6.5
本震	〃　16日午前1時25分	マグニチュード7.3

　地震から1カ月も経たない大型連休中の園内。青空の下、いつもなら子どもたちの笑顔があふれているはずなのに、静まり返った悲しい光景が広がっていた。
　園内の全域で、通路は陥没・隆起し、地中の給排水設備が大破している。獣舎はあちこちにひびが入ったり、傾いたりしている。ライオンなど猛獣4種は福岡県や大分県の動物園へ移され、姿はない。チンパンジー舎では、飼育員が毎日200リットル以上の水をポリタンクで運び、清掃や飲み水確保に奔走していた。開放型展示で人気のモンキーアイランドも被災し、クロクモザルやワオキツネザルは、鳥類のエリアなどでの"避難所生活"に。ペンギン舎は液状化した泥が流れ込み、通路をふさいでいた。
　子ども列車のミニSLは駅舎ごと無残に崩落し、ほかの多くの遊具も修理を要する

熊本地震 復興へ一歩一歩

右／熊本地震で甚大な被害を受け、長期休園が続く熊本市動植物園(手前)。熊本市東区一帯は、ブルーシートに覆われた民家の屋根が延々と続いていた。右奥が益城町方面　2016年5月4日
左上／倒壊した友誼亭　4月30日
左下／路面がめくれ上がったボリビアリスザルの展示場前　4月30日

状態だ。キンシコウとのゆかりがある日中友好の象徴のあずまや「友誼亭」も倒壊した。地震発生直後には「ライオンが逃げ出した」などの悪質なデマが、ネット上に流れたこともあった。実際は飼育員たちが発生から2時間後にはすべての動物の無事を確認していたという。動物たちの体調に心配するほどの変化はなかった。

長期休園の中の5月下旬、1969年の開園以来初めてという「ふれあい移動動物園」が始まった。初回となった熊本市西区の春日小学校では、ウサギやモルモット、ムツアシガメなどに触れた児童たちが、満面の笑みを見せていた。地震で傷ついた子どもたちの心を癒やす狙いもある。「この笑顔が、動植物園に早く戻ってきてくれるように頑張りたい」。復興へ一歩一歩、飼育員や獣医師たちの思いは一つだ。

地震で液状化した泥が流れ込んだペンギン舎の通路 4月30日

左／ワオキツネザルを引っ越しさせるため、職員に捕獲されるアカコンゴウインコ 4月30日
中／女性用トイレに緊急避難した動物資料館の魚たち 4月30日
右／本震で後ろ足が脱落したマサイキリンの骨格標本 4月30日

熊本地震 復興へ一歩一歩

倒壊したミニSL 4月30日

左／地下の給排水設備が大破した 4月30日
右／獣舎が傾き、ホロホロチョウの展示場に引っ越したクロクモザル 4月30日

地震で壊れたシマウマ舎の塀　5月4日

Index
索引

	動物名	分類	分布	ページ
ア	アオミミキジ	キジ目キジ科	中国	40
	アカカンガルー	有袋目カンガルー科	オーストラリア	55
	アカコンゴウインコ	オウム目インコ科	メキシコなど	87
	アカツクシガモ	ガンカモ目ガンカモ科	ユーラシア大陸	49
	アカミミガメ	カメ目ヌマガメ科	北アメリカ中南部	62
	アフリカゾウ	長鼻目ゾウ科	サハラ砂漠以南のアフリカ	136
	アフリカニシキヘビ	有鱗目ボア科	アフリカ	122
	天草大王	キジ目キジ科	熊本県	89
	アムールトラ	食肉目ネコ科	ロシアなど	140
	アメリカオシ	ガンカモ目ガンカモ科	北アメリカなど	96
	アライグマ	食肉目アライグマ科	アメリカなど	115
	アンゴラコロブス	霊長目オナガザル科	アンゴラ北部など	19
イ	インドガン	カモ目カモ科	インドなど	71
	インドクジャク	キジ目キジ科	インド	90
ウ	ウサギ	ウサギ目ウサギ科	家畜種	106
	ウマグマ	食肉目クマ科	中国など	91
エ	エジプトガン	カモ目カモ科	アフリカ大陸	135
	エゾヒグマ	食肉目クマ科	北海道	57
	エランド	偶蹄目ウシ科	アフリカ東南部	37

Index

	動物名	分類	分布	ページ
	エリマキキツネザル	霊長目キツネザル科	マダガスカル島	33
オ	オウギバト	ハト目ハト科	ニューギニア島など	34
	オシドリ	ガンカモ目ガンカモ科	東アジア	38
	オタリア	鰭脚目アシカ科	南アメリカ沿岸	45
	オナガキジ	キジ目キジ科	中国東北部	121
カ	カナダガン	ガンカモ目ガンカモ科	カナダなど	120
	カバ	偶蹄目カバ科	アフリカ	48
	カピバラ	齧歯目カピバラ科	南アメリカ	60
キ	キバタン	オウム目インコ科	オーストラリアなど	51
	キンイロキンケイ	キジ目キジ科	中国西南部	64
	キンケイ	キジ目キジ科	中国西南部	13
	ギンケイ	キジ目キジ科	チベットなど	61
	キンシコウ	霊長目オナガザル科	中国	143
	キンバト	ハト目ハト科	インドなど	44
	キンミノバト	ハト目ハト科	東南アジア	53
ク	クサガメ	カメ目ヌマガメ科	日本など	78
	クマモトシュ	キジ目キジ科	熊本県	142
	グラントシマウマ	奇蹄目ウマ科	南アフリカ南部	86
	クレコドリ	キジ目キジ科	熊本県	134

	動物名	分類	分布	ページ
	クロクモザル	霊長目オマキザル科	南米アマゾン川流域	52
	クロジャガー	食肉目ネコ科	北アメリカ南部	28
コ	コクチョウ	ガンカモ目ガンカモ科	オーストラリアなど	124
サ	サンケイ	キジ目キジ科	台湾	68
シ	シシオザル	霊長目オナガザル科	インド	39
	ジスリ	キジ目キジ科	日本	56
	シナロアミルクヘビ	有鱗目ナミヘビ科	北アメリカ東部	58
	シバヤギ	偶蹄目ウシ科	日本在来種の家畜	88
	シフゾウ	偶蹄目シカ科	野生では絶滅	126
	シマヘビ	有鱗目ナミヘビ科	日本	80
	シロエリオオヅル	ツル目ツル科	インドなど	22
	シロクジャク	キジ目キジ科	インドなど	46
	シロダマジカ	偶蹄目ウシ科	南ヨーロッパなど	23
	シロビタイムジオウム	オウム目オウム科	オーストラリアなど	123
セ	セキショクヤケイ	キジ目キジ科	東南アジアなど	117
タ	ダチョウ	ダチョウ目ダチョウ科	アフリカ	24
	タンチョウ	ツル目ツル科	日本など	97
チ	チンパンジー	霊長目ヒト科	アフリカ大陸	10
ツ	ツクシガモ	カモ目カモ科	ヨーロッパ北部など	132

Index

	動物名	分類	分布	ページ
ト	トカラヤギ	偶蹄目ウシ科	トカラ列島、奄美諸島など	31
ナ	ナナクサインコ	オウム目インコ科	オーストラリア	131
ニ	ニジキジ	キジ目キジ科	ヒマラヤ地方	82
	ニッポンツキノワグマ	食肉目クマ科	日本	50
	ニホンイシガメ	カメ目ヌマガメ科	日本	79
	ニホンキジ	キジ目キジ科	日本	128
	ニホンザル	霊長目オナガザル科	日本	81
	ニホンジカ	偶蹄目シカ科	日本	133
	ニホンスッポン	カメ目スッポン科	日本など	85
ハ	ハッカン	キジ目キジ科	中国南部など	116
	ハヤブサ	ワシタカ目ハヤブサ科	ほぼ全世界	84
ヒ	肥後ちゃぼ	キジ目キジ科	日本	111
	ヒツジ	偶蹄目ウシ科	世界中	138
	ヒクイドリ	ヒクイドリ目ヒクイドリ科	パプアニューギニア	72
フ	フクロウ	フクロウ目フクロウ科	ユーラシア大陸北部	77
	フラミンゴ	フラミンゴ目フラミンゴ科	西インド諸島など	54
	プレーリードッグ	齧歯目リス科	北アメリカ中央部	102
	フンボルトペンギン	ペンギン目ペンギン科	南アメリカ南部	114
ヘ	ベニコンゴウインコ	オウム目インコ科	南アメリカ北部	101

	動物名	分類	分布	ページ
	ベニジュケイ	キジ目キジ科	中国など	26
ホ	ホオジロカンムリヅル	ツル目ツル科	アフリカ南部	139
	ホッキョクグマ	食肉目クマ科	北極圏	98
	ポニー	奇蹄目ウマ科	家畜種	129
	ボリビアリスザル	霊長目オマキザル科	コスタリカなど	94
	ホロホロチョウ	キジ目キジ科	アフリカ	32
マ	マサイキリン	偶蹄目キリン科	ケニアなど	14
	マレーグマ	食肉目クマ科	マレーシアなど	66
	マンドリル	霊長目オナガザル科	アフリカ西部	118
ミ	ミナミシロサイ	奇蹄目サイ科	南アフリカなど	18
	ミミナガヤギ	偶蹄目ウシ科	家畜種	125
	ミヤマハッカン	キジ目キジ科	ネパールなど	100
ム	ムツアシガメ	カメ目カメ科	東南アジア	59
	ムネアカカンムリバト	ハト目ハト科	ニューギニア島	30
メ	メガネカイマン	ワニ目アリゲーター科	南アメリカなど	20
	メンフクロウ	フクロウ目メンフクロウ科	サハラ砂漠を除く全世界	36
モ	モモイロインコ	オウム目インコ科	オーストラリアなど	65
	モモイロペリカン	ペリカン目ペリカン科	アフリカ北部など	17
	モルモット	齧歯目テンジクネズミ科	南米	76

Index

	動物名	分類	分布	ページ
ヤ	ヤエヤマイシガメ	カメ目ヌマガメ科	日本	70
ユ	ユキヒョウ	食肉目ネコ科	ヒマラヤ山脈	69
ヨ	ヨツユビリクガメ	カメ目リクガメ科	中東アジアなど	92
ラ	ライオン	食肉目ネコ科	アフリカ	104
	ラマ	偶蹄目ラクダ科	南アメリカ	16
ル	ルーセットフルーツコウモリ	翼手目オオコウモリ科	タイなど	130
	ルリコンゴウインコ	オウム目インコ科	南アメリカ	12
ワ	ワオキツネザル	霊長目キツネザル科	マダガスカル南部	93

あとがき

熊本日日新聞社写真部次長　岩下　勉

　「動物園ロスになってます」。2016年1月17日に連載を終えた直後、毎回楽しみにしていたという読者の女性から、がっかりした声で電話をいただきました。人気の朝ドラ終了時に流行語になった「あまロス」以降、すっかり定着した「○○ロス」ですが、新聞の一つの連載にも使ってもらうとは思ってもいませんでした。

　熊本市動植物園のすべての動物を紹介する「素顔の動物園」は、2015年4月3日から週末を中心に本編102回、番外編9回を連載しました。冒頭の電話だけではなく、連載中から想像もしていなかったほど多くの反響が寄せられました。感謝の気持ちを込めて、一部を紹介します。

　「こんなに夢中になったコーナーは熊日を小学生の頃から読み始めて40年で初めてです」「5歳の息子が大好きで、3世代でスクラップして楽しんでいます」「子どもたちが小さい頃よく通っていた動植物園にまた行きたくなり、娘と2人で行ってきました」「写真がすごいなぁ。次はどんな動物かな？　ワクワク」

　取材を担当したのは、写真部の横井誠記者と谷川剛記者です。読者の反響は、2人への何よりの声援になりました。横井記者は実家がペットショップで、小さい頃から動物カメラマンにあこがれていたという動物好き。今回の取材では、「一般の来園者と同じ場所から撮影する」という自主ルールを提案してくれました。読者が双眼鏡を持っていけば、同じ表情

を探せるからというのが理由です。その分、撮影には制約をかけることになるのですが、谷川記者とともに「図鑑のような写真じゃダメ。喜怒哀楽が伝わる1枚にとことんこだわりたい」と、超望遠レンズを抱えて動植物園に通い続けました。谷川記者は保育園児のパパです。休日の家族サービスの場所を動植物園にして何度も動物たちに会いにいきました。掲載した写真は、1000枚以上撮影して、ようやく納得がいった1枚というものも少なくありません。2人がこだわった分だけ、すべての動物たちの「素顔」は魅力的です。普段は脇役扱いの動物たちも、主役級に輝いています。

　連載終了から3カ月後の4月14日と16日、最大震度7が2度襲う熊本地震が起きました。熊本市動植物園の被害は甚大で、「再開まで1年以上」という長期休園を強いられました。熊本県民は今、本当の「動物園ロス」になってしまいました。多くの動物たちは園内に残っているのですが、会いたくても会えません。ガイドブックになるはずだったこの本は、結果的に地震直前の動物たちの姿を伝える1冊になってしまいました。みなさんがページをめくって、動物たちとつながる気持ち、会いたい思いを持ち続けていただければ、それが熊本市動植物園の復興を後押しする力になると信じています。

2016年7月

素 顔 の 動 物 園
The real zoological garden

平成28年8月15日　第1刷発行
平成29年2月 7日　第2刷発行

発行・編著　熊本日日新聞社
制作・発売　熊日出版（熊日サービス開発株式会社出版部）
　　　　　　〒860-0823 熊本市中央区世安町172
　　　　　　TEL096-361-3274　FAX096-361-3249
　　　　　　https://www.kumanichi-sv.co.jp/
ブックデザイン　内田直家（ウチダデザインオフィス）
印刷　　　　シモダ印刷株式会社

ISBN978- 4-87755-538- 2 C0072
© 熊本日日新聞社 2016　Printed in Japan

本書のコピー、スキャン、デジタル化等の無断複製は著作権法上での例外を除き禁じられています。本書を代行業者等の第三者に依頼してスキャンやデジタル化することは、たとえ個人や家庭内での利用であっても著作権法上認められておりません。